The Master Photographer's Lith Printing Course

A definitive guide to creative lith printing

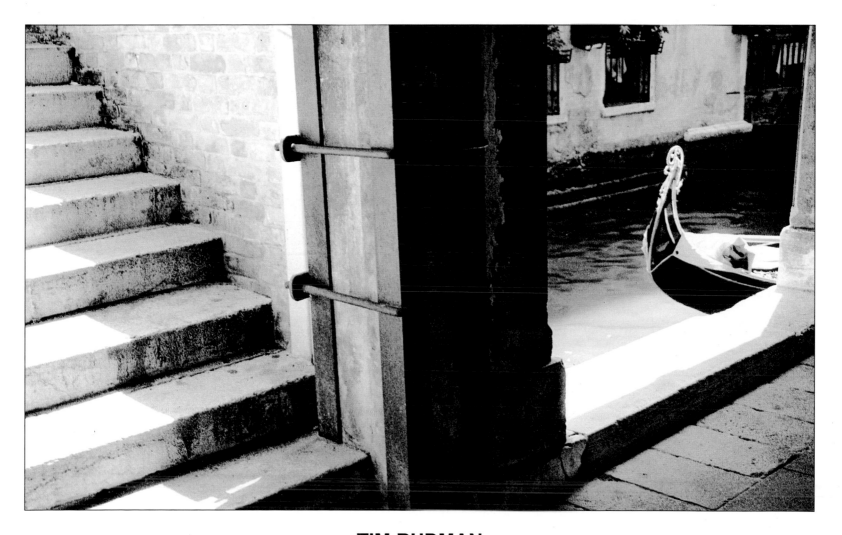

TIM RUDMAN

ARGENTUM

First published 1998 by Argentum, an imprint of
Aurum Press Ltd, 25 Bedford Avenue, London, WC1B 3AT.

ISBN 1 902538 02 1

Origination - Graphic Ideas, London, N1
Printed in Singapore by Imago

To my family – Ingrid, Natalie and Chris – for their patience, encouragement, support, keyboard skills, computer know-how and for letting me take over the house with prints and manuscripts once more.

My grateful thanks for their support and assistance are due to;

Fotospeed
Hans O. Mahn
Ilford Ltd
Kentmere Ltd
Kodak Ltd
Mr Cad
Silverprint
Speedibrews
Sterling UK
Tetenal Ltd
Berten Steenwegen
Chris Rattue
Garry Hume
Gary Andersen-Jones
Jeremy Roy
Jim Cottrill
John Herlinger
Keith Dutton
Martin Reed
Michael Maunder

Contents

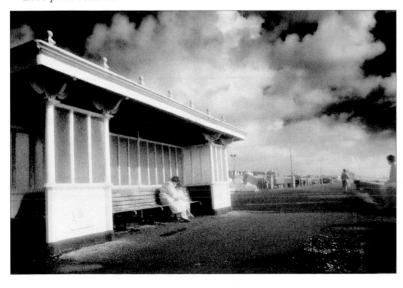

Introduction

There has never been a better time to begin lith printing. Since the time when I devoted a chapter to lith printing in my first book, *The Photographer's Master Printing Course,* there have been considerable developments in this field.

There are now more papers and more developers for the lith printer to choose from than ever before. There are also new problems – like pepper fogging – and fortunately new solutions as well. In addition there are more experimental techniques now known that incorporate yet a wider selection of papers.

In Europe, we have seen a veritable explosion in the popularity of lith prints, that now appear regularly on the Salon wall as well as in fashionable, glossy magazines, both in the editorial illustrations and in the advertisements. At present these are mostly in the conventional lith printing style rather than the more creative or experimental genres. But this too is changing, for this, it seems, is definitely the era of the lith print.

In America, it would appear that this process is not yet so widely practised or so well known – but it will be! It is my experience that once introduced to the seductive beauty and creative versatility of this process, most darkroom workers take to it with enthusiasm.

Given its rapidly increasing popularity, it is surprising that relatively little has been written about lith printing – and even less about its more advanced and creative applications.

The chemistry behind infectious development – the process that drives lith printing – is even more obscure and as far as my researches show, is poorly understood and has never been previously written up in the public domain. It is of course not necessary to understand chemistry to make good prints and although a big yawn for some, others may find the Advanced Class section on this subject will provide the key to fine control. We all work differently.

At the time of writing, this is the only book on this lovely process and its aims are simple;
- to introduce lith printing to the beginner and make it easily accessible
- to provide the keys to control the process, for the intermediate worker to achieve greater consistency
- to give the advanced worker ideas and inspiration for creative expression and further experimentation.

It also aims to demystify and simplify a process that has, unjustifiably, become surrounded by mystique and misinformation.

You will find that this book is both technique orientated and detailed. Technique, not for the sake of technique, but because no matter how visionary you are, it is technique which allows you to communicate your vision to the viewer successfully. Detailed – because as the saying goes – "the devil is in the detail". I have often felt that it is the absence of crucial detail in many how-to-do photography books that leads the beginners to failure, loss of confidence and a logical, but probably erroneous assumption, that they can't succeed – so they give up.

This book also aims to be soundly practical and therefore I have included a data and quick reference section at the end as well as highlighted practical tips throughout the text.

I hope this book and the process of lith printing give you as much pleasure as they have given me.

Tim Rudman

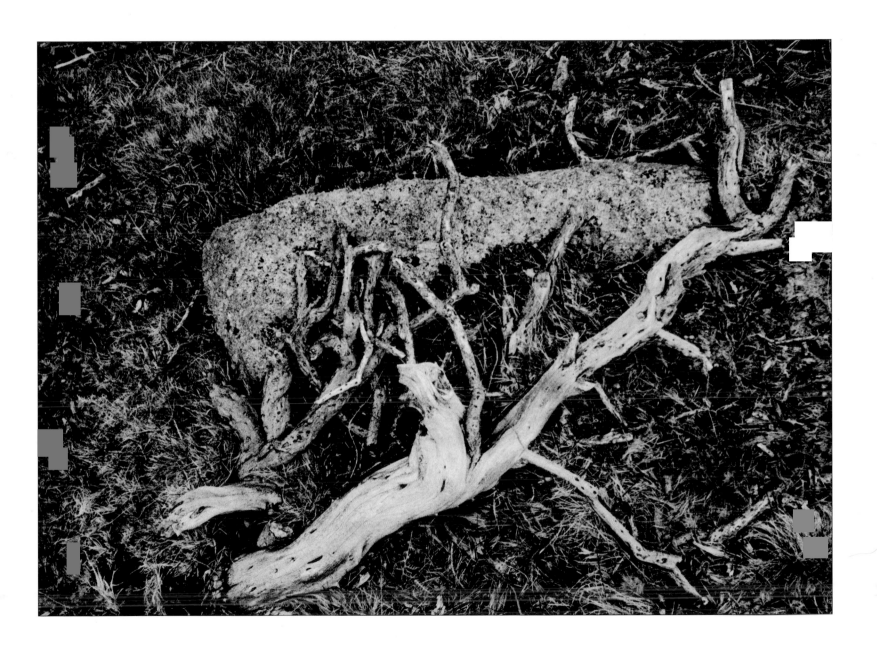

FAQ

Ten frequently asked questions about Lith Printing

Q. What is lith printing?

A. Lith printing is the technique of heavily over exposing a black and white, or colour, negative onto a suitable black and white paper and then only partially developing it in very dilute lith developer to produce a colourful monochrome print – with special properties and characteristics in terms of tonal distribution and response to toners.

Q. What's in it for me?

A. A frequent question this, although it comes in different guises. The answer is that lith printing will not only expand your printing skills, but also your creativity. You will think differently, print differently, and interpret differently. You will discover more in your negatives and in yourself as an artist, as you start to look at picture making in a different way.

Q. Isn't this going to be too advanced for me?

A. Absolutely not. Making a lith print is actually very easy. Learning to control it takes more practice of course, but this is true of normal printing as well. Sometimes beginners find lith printing easier than advanced workers do, as the more accomplished printer may occasionally find it initially more difficult to 'unlearn' the normal good printing rules that don't apply to lith printing!

Q. Isn't it all high contrast graphic design stuff?

A. No. Don't confuse lith printing with lith negatives. You can use any sort of regular negative and produce prints that have quite different properties to your usual prints. They can be very delicate as well as graphic – or anything in between.

Q. Do I need special equipment and materials?

A. Normal black and white dish development is used, so avoid slot processors. A darkroom torch is very helpful but not essential. Lith developer is required and is readily available. Details of equipment and materials together with a list of suppliers is given in this book.

Q. What is the best paper to start with?

A. It depends very much on the effect you are after. A list of suitable papers is given in Chapter 2 (Equipment and Materials) along with their properties and clear guidance as to which ones give what effects.

Q. What sort of negative is the best choice for lith printing?

A. Any subject can lend itself to lith printing and any make of black and white film is suitable. Infra-red negatives lend themselves particularly well to the process. Colour negative film can also be used for its fine grain and different tonal resolution.

Q. I can't afford to keep a lot of different papers. Are there papers that are good for normal use as well as for lith printing?

A. Yes indeed, there are many. Guidance on these is given in Chapter 2 (Equipment and Materials).

Q. I can't find some of the papers mentioned in your previous book's chapter on lith printing on sale in the United States. Are they available?

A. They are all available – but some are under different names. A table of UK/US/Australian name equivalents is included in the final section of this book.

Q. It sounds complicated. Is it worth it?

A. Actually it is not complicated – just different and yes it is worth it! Most people who try it get addicted to it quickly – the results can be so enchanting. It will take your photography onto another plane.

Q. Is lith printing something new?

A. No. It was very fashionable in some professional printing circles in the seventies. It almost disappeared after Kodalith LP paper was discontinued later that decade. There are now more suitable materials than ever before and lith printing is now witnessing a popularity explosion.

Chapter 1

Lith Printing – An Overview

In this Chapter:

- *What lith printing is (and isn't)*
- *Why bother? Properties and attractions*
- *Image colour and grain size*
- *Infectious development*

Lith printing can be a highly individual and personalised process;

 – Seductive and subtle
 – Gutsy and graphic
 – Eye catching and "off the wall".

I have heard lith prints described in all those terms and their apparent contradiction is explained by the versatility of this printing process, that is capable of producing such dissimilar results in different hands. Its flexibility allows considerable individual interpretation and this may be partly responsible for the great resurgence of interest in lith printing.

Over the last few years lith prints have been used for their distinctive appearance in increasing numbers in Salons, Exhibition work and Fine Art photography, as well as in glossy publications and advertising.

Apart from changing fashions, this is also due to the fact that there are currently more suitable papers available now, that will lith print, than has been the case for many years. Also, because of an increasing awareness of the process, more photographers are finding in it new ways of expressing themselves through their pictures.

IS IT DÉJA VU – *ALL OVER AGAIN*?

If you experience a sense of sameness or have that 'predictable formula' feeling when the print emerges from the fixer, you may be in a photographic rut – in which case this book is definitely for you – as lith printing is very different.

Alternatively, you may be one who likes to push out the boundaries or explore new ways of expressing yourself. New skills will usually allow new and sometimes better interpretation of some negatives and lith printing is no exception, for it has unique properties that cannot be produced in other ways.

These may be the answer to a printer's prayer for some difficult negatives or they may just allow you to make a different type of image. In either case I should warn you that the process may become addictive!

WHAT IS LITH PRINTING?

Lith printing has nothing whatsoever to do with lith film, the making of ultra high contrast negatives, tone separation, bas relief, sabattier effect or any of the other processes involving graphic art film. It is a printing technique using normal negatives and heavily overexposing them – usually by two to three stops – onto a suitable black and white photographic paper. Not all papers will do this. This paper is then only partially developed in highly diluted lith developer. By utilising its particular mode of action, known as infectious development, this may yield a print typically with black shadows, coloured mid-tones and white highlights.

These mid-tone colours vary both with the paper and the technique, and are typically caramel, olive, peach, pink or red. They also have distinctive properties in terms of contrast and tonal gradation in both highlights, and shadows, as we shall see later.

This process is more time consuming than conventional printing and although it can be initially frustrating, it is ultimately very satisfying. It is very flexible and can be adapted to suit the mood of the image and the printer. Because the possible end points can be so different, a clearly pre-visualised objective is especially important, although as always experimentation can yield unforeseen yet pleasant surprises.

DIFFICULT?

Lith printing also has a reputation for being both difficult to do and impossible to duplicate as each print is a one-off in a dynamic process with too many variables to permit an exact reproduction. The latter is often quoted as one of the attractions of lith printing, as each print is a unique work – infinitely more individual than one of a limited edition series of a conventional print. If, however, like me you are something of a control freak in the darkroom, I hope to show you firstly that lith printing is not at all difficult and secondly, with care and practice, pretty tight control is possible.

However, if you already find it difficult to produce two identical conventional prints, you will find it harder to do so with lith printing. This need not be a bad thing, especially when starting, as these subsequent versions

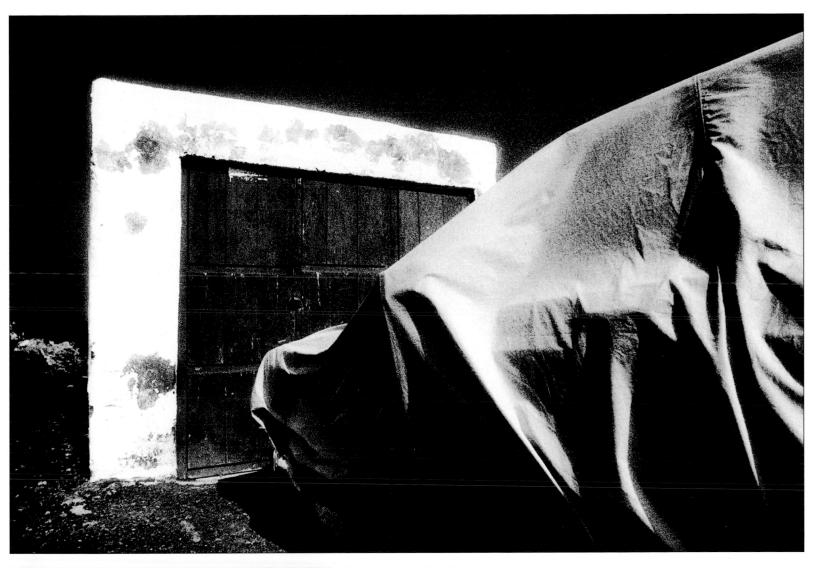

Lith printing can give a different feel to a picture by virtue of the altered tonal relationships it can produce – as the before and after pictures demonstrate here.

The tones and textures shown in the tarpaulin of the finished print above, simply cannot be achieved with normal printing techniques.

The oddness of a door apparently leading into nothing is enhanced by a dark background that builds up quickly through infectious development.

Printed on Sterling Lith paper, untoned.

may turn out to be more appealing than the first, and will also open your eyes to some of the alternatives available.

SO WHY BOTHER?

If it's so tricky, you may wonder why should you bother. In my view there are several very good reasons;

• Precisely because it can be so beautiful, different and personal. Its flexibility offers almost limitless ways of interpreting a negative. Mind you, this can in itself cause difficulties in decision making if you do not have a clearly pre-visualised end product!

• Lith prints are often quite different in appearance to conventional silver halide prints. They can be more expressive and, consequently, you may also find the process personally liberating.

• Lith prints have their own intrinsic beauty and distinct properties – printing hard in the shadows but soft and delicate in the highlights. Because this is the only way of achieving this on the same print (even split-grade printing can't produce the same effects as the soft exposure always softens the hard), it may be the only way to print some negatives the way they were pre-visualised, as in the image on the opposite page – especially with 35mm, where individual processing for each frame is impractical. Alternatively, it allows new interpretations in the darkroom, that were never preconceived.

• Lith prints can respond particularly well to selenium and gold toners. The effect can be very subtle or sometimes quite spectacular in a way that you will never see with conventional silver halide prints. The image colours can also be changed by various simple after treatments – with ferricyanide for example – to give even greater control.

• Contrast can be controlled entirely in the printing from grade zero to grade six plus, depending on the materials and regardless of the nominal grade of the paper. Results can vary from gentle and subtle to graphic or bizarre.

• Even the one-off factor has the attraction that each print may be unique. Although I believe that with care and experience extremely close reproduction is generally possible, there are some lith printing and toning combinations where this is difficult to achieve.

Image colour and infectious development

The image colour of an untoned silver halide print depends very much on the grain size in the emulsion. A pure silver bromide emulsion would be relatively large grained and cold-toned – neutral black or blue-black. A silver chloride emulsion on the other hand would be very fine grained with more delicate tones and warm brown-blacks. Almost all papers today are a combination mainly of these two with one or other contributing more to the paper's properties – as the terms bromochloride and chlorobromide suggest. Other papers incorporate iodide – another halide.

However, grain size in the emulsion is also related to the degree of the development. It starts very small and grows to full size when development is complete. Image colour therefore changes during the process of development according to the grain size as one would expect. Exploiting this through infectious development is the basis of lith printing.

Infectious development is a property of high energy, high contrast lith developers. Simply stated, it means that the darker a tone becomes in the developer, the faster it develops. The faster it develops, the darker it becomes – and therefore the faster it develops, leading ultimately to an almost explosive acceleration of development in the dark tones. Ordinary developers cannot do this. Lith developers contain large quantities of hydroquinone in a very alkaline environment – usually pH 11.5 to 12 – in which environment hydroquinone can produce very high contrast. Aggressively active semiquinones are produced that develop a chain reaction, culminating in this exponential acceleration in development. High dilution of the developer aids this by further lowering sulphite levels, that would otherwise divert activity out of this spiral.

A knowledge of the chemistry involved is not necessary to make a print of course, but it will help later in understanding issues such as pepper fogging, replenishment, Old Brown, and generally controlling the process. So for those interested, I shall explain it simply and in more detail in Chapter 6 (Lith Printing Advanced Class) – together with some practical *Takeaway Tips* for those not comfortable with chemistry.

Whatever the chemistry – all you really need to understand about infectious development in order to make a lith print is that

<div align="center">

darker = faster
and that
faster = darker!

</div>

If left until development was complete, the lighter tones would all eventually develop fully to give a dark, cold toned and heavily over exposed print. However, because of the nature of infectious development the print can be snatched at any time when the blacks reach the required density, but the lighter tones are still lagging way behind. Over exposure ensures that these partially

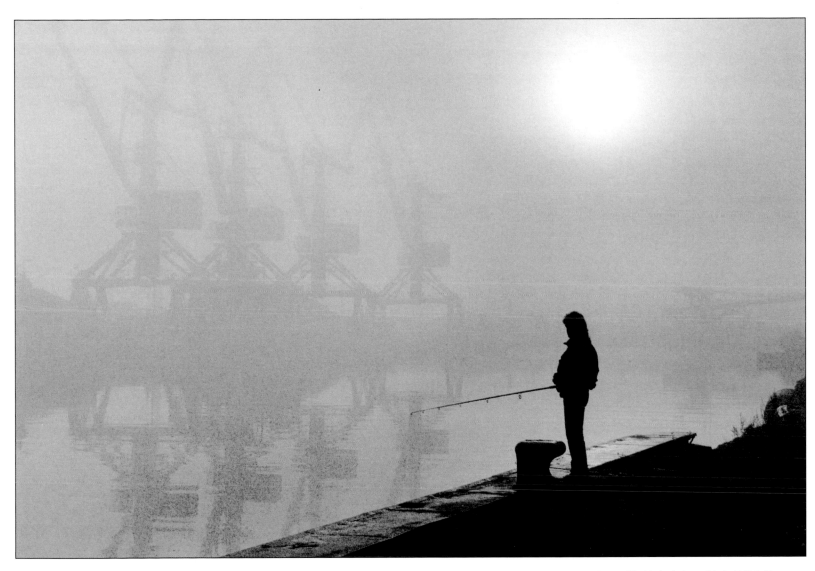

developed light tones have sufficient density. Dilution of the developer slows the process down and widens the gap between the fast and slowly developing tones.

HARD IN THE SHADOWS – SOFT IN THE HIGHLIGHTS

Because the snatch-point in the development of a lith print is determined when the rapidly progressing shadow tones are ready (and that is an entirely subjective judgment), these dark tones exhibit full grain size, cold colour or tone and high contrast properties in terms of tonal separation. The light tones however, as they are still far behind in development, are very fine grained and they can be wonderfully soft and delicate, as well as colourful.

This striking combination of printing hard in the shadows and soft in the highlights is the hallmark of a lith print, and cannot readily be achieved with conventional printing. Of course, the soft or hard qualities of a lith print can also be individually exploited by making high-key or low-key lith prints respectively and we shall look at ways of doing this later in the book.

FINALLY, WHAT IS A SUITABLE SUBJECT FOR LITH PRINTING?

This is a question I am often asked, especially before workshops when participants want to select negatives to bring with them.

The answer is that just about any subject matter can be suitable for this process, although some lend themselves particularly well to it. Perhaps the question ought to be turned around to what style of lith printing is best suited to this subject?

"Hard in the shadows, soft in the highlights" is a characteristic of lith printing.

Although this early morning negative prints easily as a low key dusk scene with normal processing, it is extremely difficult to print with a rich black silhouette whilst holding soft, delicate, light tones through the mist and retaining the outline of the sun.

Even when using split-grading, water bathing and selective exposures the conventional print lacks conviction as a early morning mist shot. It lith prints easily, as the density of the highlights and the blacks can be controlled independently of each other.

Printed on Sterling Lith Paper, split-toned in gold and selenium toners.

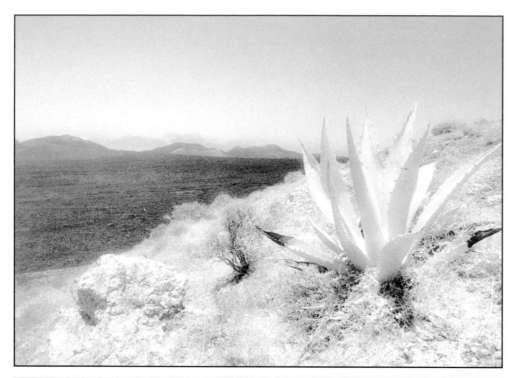

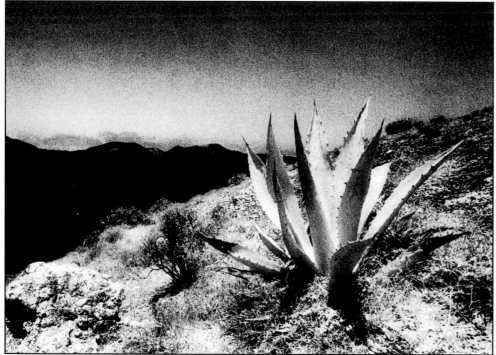

Lith printing allows the printer great scope in interpreting negatives in very different styles, as these two straight prints, on Sterling Lith Paper, demonstrate. Contrast, grain size, image colour and density are all easily controlled by the exposure and development of the paper.

One thing I hope will be quickly apparent from this book is that lith printing is a flexible process with many different faces. Lith prints can be graphic and gritty or soft and ephemeral. They can be monochromatically coloured, duo coloured or multicoloured. They can be weird and wacky, semi abstracted, pseudo-solarised or manipulated in a variety of ways. Most of all the process offers a range of additional interpretative and expressive options to increase communication through your pictures. As always it is a question of choosing the right approach for the subject.

The tree with exposed roots used to illustrate contrast control (page 46) is a good example of an image that does not benefit from straight lith printing, at least on Sterling Lith paper. It looks much better split-toned as on page 103. Alternatively, had it been printed on Kentona and toned in selenium like the Horsetail Falls picture (page 88), this could have been very successful.

However, the Thai Boatman (page 31) is a graphic interpretation that did need the characteristics of Sterling Lith paper and clearly benefits from its use – but so on the other hand do some of the more delicate works, such as Front Garden (opposite).

When deciding on material for lith printing, first consider what interpretation you have in mind and then choose the technique that facilitates it, rather than selecting the process first, possibly inappropriately, and then battling with it. Lith printing can certainly do things that other techniques cannot do, but it is after all only a tool – a means to an end. Technique for technique's sake only ever has a limited appeal. It is the application of it that is important.

Portraits often lend themselves particularly well to lith printing. High-key renditions can be printed with soft milky skin tones, while the lower values can either be stopped at soft greys, or allowed to proceed to deep blacks, as in the pupils for example. Alternatively, they can be given the stark, gritty treatment to emphasise texture or character.

Landscapes are also often suitable subjects for this process. Dark tones can be separated from low mid values convincingly. Gold toning may add atmosphere particularly to cold scenes, and selenium on Kentona, Art Classic or Tapestry may give lovely soft multicolour effects, particularly in mist or haze. With the recession of aerial perspective the colours may subtly change with the distance.

Snow scenes too can often benefit from lith printing. This is not only because of the toning potential of lith prints, but also because the tone and texture of the snow can be controlled through the exposure quite

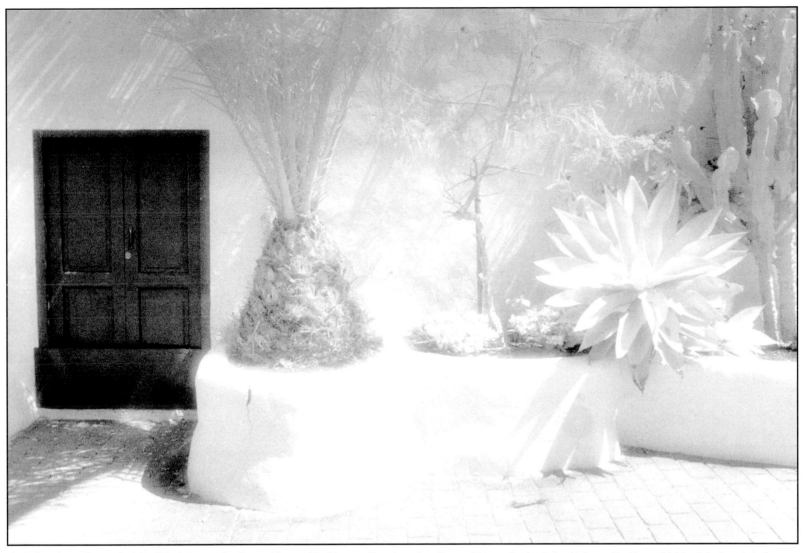

This Sterling Lith print illustrates the ability of lith printing to produce the most delicate, grainless light tones with an almost ethereal beauty, whilst separating deep shadow detail even without the use of dodging. It also demonstrates the natural affinity that lith printing has with infra-red photography.

independently of the dark tones, which are determined by development and snatch-point. These low values can therefore be rendered either as soft atmospheric greys or stark blacks, but without affecting the tones in the snow.

Graphic images of all sorts are obvious candidates for this process, as very high contrast effects are easily achieved with lith printing. Still life studies too can benefit from the soft highlights and hard shadows typical of lith printing.

Street scenes often have a raw edge to them as lith prints, which can add to the way they communicate to the viewer.

Finally, if you are involved with infra-red work, this process is a *must* for you. Lith printing and infra-red negatives were absolutely made for each other.

Infra-red photography is much about the celebration of highlights and one of the main attributes of lith printing is also of course the beautiful, and delicate, rendition of highlights. The marriage of these two approaches can be magical.

Although no subject list of this sort can ever be comprehensive I hope the above suggestions, together with some of the images to be found in this book, may give you some inspiration.

The following series of pictures was made on Sterling Premium F Lith paper, devloped in Kodalith liquid concentrate developer, at 20°C, diluted 1A + 1B + 28 water. They illustrate the typical colours of untoned lith prints on this paper.

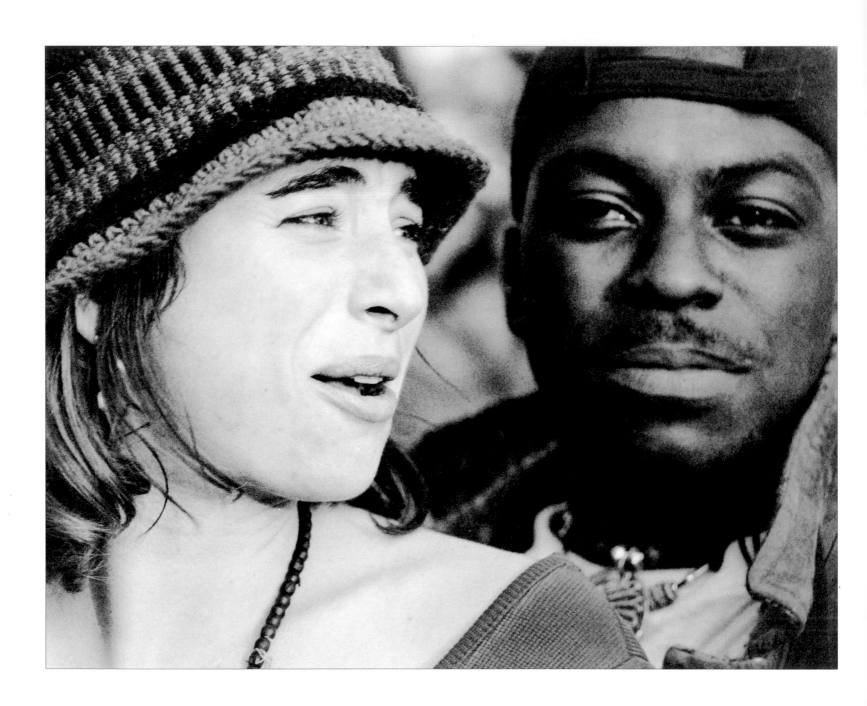

Chapter 2
Equipment and Materials

EQUIPMENT

Most monochrome darkrooms are perfectly suited to lith printing, but it is worth making a few points under this heading.

• Safelights

These are of particular importance in lith printing.

Development times are longer than in conventional print making and may be very long. I often use 20 minutes or more, although 7 to 10 minute development times are common. If your safelighting is questionable, this process will expose its weaknesses and fogging will occur.

I suggest you carry out a modified safelight check using extended times to reflect the longer exposure and development times involved. Both light and chemical fogging can occur in lith printing and it helps to know which one you are dealing with! Light fogging can be avoided by careful safelight testing. Chemical fogging may easily be avoided by simple developer additives as we shall see later.

Suggested safelight test procedure

1). Position your anticipated safelights in their usual place and leave them on. For choice of safelight colours see below.
2). Select a fast paper (see Paper Speed chart on page 116).
3). Use a test strip method to expose a sheet of this paper to light from your enlarger. With the negative carrier empty, expose a series of steps to determine how much exposure will produce a light grey fog when fully developed in normal print developer. The exact tone is not critical as long as it is just light grey. It is important that you do not do the safelight test on paper that has not been pre-exposed at all.
4). Expose a new sheet of paper for the time determined above and lay it undeveloped and face up on your wet bench.
5). Cover a lengthways strip on the left and mark a series of steps with a waterproof marker on the right, as shown above.
6). Again using the test strip technique, cover the strips

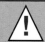
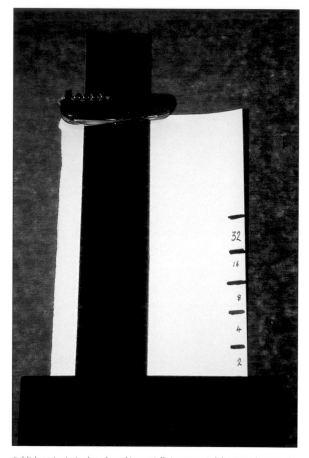

Safelight testing is simple to do and is especially important in lith printing because of the extended development times involved. Shown here is a test being made on flashed paper as described in the text. A vertical strip of card is held in place, by a weight to stop it moving, as the marked strips are progressively covered at timed intervals.

progressively from one end, doubling the exposure each time i.e. 1, 2, 4, 8, 16, 32 minutes. The last section will have been exposed for 64 minutes, that should be enough for even the slowest lith print worker!
7). Develop fully in normal print developer (not lith developer) with safelights off. Fix, wash and dry.
8). Examine the dry strip and look for the first strip on the right side to show an extra tone compared to that on the left. **Important:** *Never* assess this strip wet as the

lightest fogging may not appear until dry down has occurred.

This indicates the longest time that the fastest paper you will be using can be exposed to your safelight without fogging.

As you may be giving exposures of several minutes (depending on your enlargement, negative density and paper choice) and developing for say 10-20 minutes, your 'safe time' should not be less than 30 minutes – and preferably a bit longer to allow for the cumulative effect of safelight exposure during repeated opening of packets or paper drawers, trimming, cutting and general handling.

If your safelights are not safe for this time;

1). If you have more than one safelight re-test them individually.
2). Check them for unsafe light leaks.
3). Move them to a more distant position or partially mask them.
4). Check if the filters need replacing as they may fade or craze over a period of time.
5). Check for extraneous light leaks from outside the darkroom. If necessary, repeat test at night with outside lights off.

Safelight Colour – The colour of safe lighting required is dictated by the paper in use and not by the process. I have red and amber in tandem, and switch over according to the paper I am using. Sterling Premium F Lith paper – the only lith paper dedicated to lith printing – requires red. Some other papers giving pleasing results may require amber. If in doubt use red which is generally safe for most papers. Amber gives better visibility but is not suitable for all papers. See below and the Paper Characteristics chart on page 111. A table of safelight codes and colours is also provided on page 117.

• Darkroom or safelight torch

I regard this as an essential piece of kit for lith printing. The reason for this will become clear. For years I used a Jobo darkroom LED torch until I was introduced to the Mini Maglight, which I have found to be vastly superior.

This American outdoor pursuit torch comes with a red filter designed to preserve night vision. When used in the darkroom it is so bright that I initially doubted its safety, but have found it entirely reliable in the darkroom if used with discretion.

It really makes child's play of judging the critical snatch-point in lith printing. It does have a hot-spot

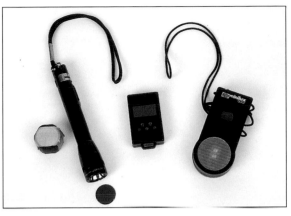

A darkroom torch is a valuable aid in lith printing, as development is by inspection. On the left is my Mini Maglight with its red filter and the diffusing tape I use. In the centre is R.H.Design's darkroom torch (red) and on the right, the Jobo Minilux LED darkroom light (amber).

when used at close quarters, but I find a piece of diffusing tape across the end eliminates this and makes it easier to use by reducing the brightness, and giving an even light field.

Just on the market is a new red safelight torch from R.H. Designs. Of quite a different design, it sits in the hand and is operated by a click switch. From a practical point of view this means it can be operated with one hand, which is a definite plus. The maglights's twist action means that it is a two-handed operation, that at times can be a nuisance when one hand is busy.

• Trays

Processing trays should be used rather than slot processors, as development is by inspection, not by the clock. Politically correct or not, size is important – and in this case generally the larger, the better. If the print fits the dish too snugly, excessive developer agitation at the edges is likely and this can result in visibly uneven development in lith printing. It will also be difficult to grab the edge of the print and snatching the print at the right moment is critical in this process.

Finally, it is wise to be able to accommodate a large volume for two reasons: Firstly, the developer is often very dilute and consequently prone to sudden exhaustion, and development stand-still. Secondly, the developer matures with each print passed through it, giving noticeable differences in print colour. A large volume will give better consistency. I find four litres a convenient quantity in a 20" x 16" tray, but it varies according to the dilution chosen as well as the size and number of prints to be processed.

Temperature control – A thermostatically controlled dish warmer for the developer is useful but not essential. Although a range of temperatures can be used, it is in the interests of consistency and predictability to be able to control as many variables as possible, including temperature. Later in this book you will find some high

Tip

In workshops I often see people poking their prints in the developer as if trying to prod them into action. It doesn't! However, the invisible results of this will return to haunt you in subsequent toning or bleach and re-development techniques.

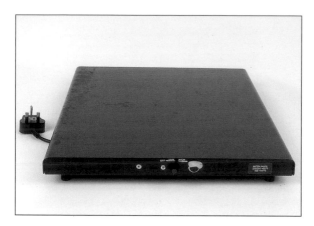

A good dishwarmer is useful for consistency in lith printing and is essential if high temperature techniques are required. This one is made by Nova and will heat up to 40°C. I put blu-tack over the thermostat light to guard against possible fogging through the overhang of a 20" x 16" tray during long development times.

Although not essential for lith printing, an f-stop timer (far right) is very helpful for working out the lith exposure from your normal test strip and for adjustments in contrast and highlight detail. It is invaluable in conventional printing also.

Good tongs are worth paying extra for. These stainless steel Kenro tongs are excellent and have replaceable rubber tips.

temperature lith printing techniques, where a constant developer temperature of 40°C is preferred. A good dish warmer is invaluable here.

• Tongs and Things

Because of the need to snatch a print quickly and smoothly from the developer without delay, when the moment arrives, a good pair of tongs that grip securely is essential if you do not wish to use your fingers. Cheap plastic tongs will not hold a wet large print reliably and may damage the emulsion. I use Kenro print tongs, that are stainless steel with replaceable soft rubber tips and grip easily without undue pressure. They are by far the best I have found to date.

If you are not sensitive to lith developer, fingers are a convenient option, but cross contamination occurs easily resulting in marked prints.

Gloves are an alternative, if you do not like chemicals on your hands – but beware – some latex gloves have a component that stimulates infectious development at points of contact, resulting in black blotches and streaks on the print. Vinyl gloves are often better in this respect.

Whatever your preference, only handle prints by the unexposed rebate – do not poke the print in the picture area.

In workshops I often see people poking their prints in the developer as if trying to prod them into action. It doesn't! However, the invisible results of this will return to haunt you in subsequent toning or bleach and re-development treatments.

• F-stop Timer

An f-stop timer is not essential for lith printing and I mention this only by way of explanation, as you will find exposure adjustments throughout this book are described in f-stops. Any darkroom timer is suitable for lith printing.

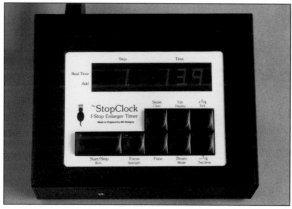

As with using a camera, I find f-stops are a convenient and logical way of thinking in terms of image lightening or darkening. It is especially useful when changing print size as the printing map remains always the same. The only thing that changes is the initial exposure time.

The f-stop timer allows you to punch in dodging and burning-in steps as fractions of f-stops, that it then displays in seconds. The f-stop/time relationship is not linear and I have included an f-stop calculation grid at the end of this book.

The excellent Stop Clock – I believe the only f-stop timer currently in production – is also made by R.H. Designs (see Suppliers on page 122) and in fact it functions as both analogue and f-stop timer, giving the best of both worlds.

• Sound Advice!

There are two further important pieces of kit in my darkroom, both of which I particularly recommend for lith printing. The first is a radio/tape/CD player. This gives me a constant supply of opera, blues and rock 'n

roll during the long sessions I spend in the darkroom. I am never quite sure if the music I choose influences the way I print or vice versa – but it certainly fills the time during those long development sessions in lith printing.

The second is a large waste bin that I have renamed, the Learning Bin! Not being afraid of making mistakes is a vital part of learning and these rejects should not be regarded so much as failures, but rather as stepping stones to success.

MATERIALS

• Papers

"A footnote in photographic paper history" – is how Martin Reed, an expert in photo-chemistry and materials, described Kodak's Kodalith LP paper in an article he wrote entitled *Yesterday's Papers*. He was discussing the place that certain Graphic Arts products had acquired outside their normal field and particularly in the area of pictorial photography. He went on to say that since Kodalith LP was dropped in the mid 1970s, no other papers, when lith printed, had ever quite captured the effect of it.

This paper had in the hands of a few expert printers – notably Gene Nocon – become responsible for the emergence of a highly fashionable photo art printing style that became known as lith printing.

My introduction to lith printing came in about 1980, when Gene Nocon showed me some of his lith prints in his London darkroom. At that time he still had a small supply of this, by now historical, paper and lith printing was already a vanishing art. Oriental Seagull paper became Kodalith LP's next best successor, but lith printing really started to slowly re-emerge after the introduction of Sterling Lith paper in the early 1990s, and its star is now rising more rapidly than before.

It was, therefore, with mixed feelings that I responded to Martin Reed's generous offer to send me some Kodalith LP paper. I say mixed feelings because, on the one hand, I was excited and curious to try this legendary paper that I had never printed on – rather like opening a rare wine – but on the other hand I was aware it had to be well over 20 years old and was less likely than the wine to have survived with all its qualities intact!

I processed the first sheet well into a printing session in well-used lith developer and on eagerly going to white light was astonished to find…pepper fogging! This is something currently confined to, and until the cure was discovered was once the curse of, Sterling Lith paper, see Chapter 5 (Pepper Fogging, Highlight Fogging and Developer Replenishment). A quick tweaking of the

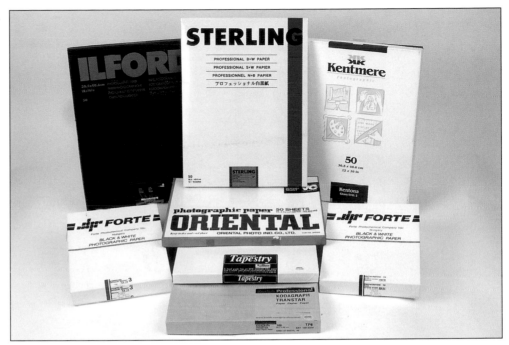

Not all papers will lith print. These and other suitable papers are described in the text.

developer however revealed that 20 years old or not, this paper had lost none of its magic and indeed printed like no other. Flexible, high-key, low-key, brilliant whites, luscious blacks – it had a character and surface of its own that was beautiful in the hand and hard to describe on paper. Obviously, it was too good for production to be allowed to continue and it was consigned to history's dustbin to join the other great papers of yesteryear!

However, looking on the positive side, we now have available for lith printing a much larger range of printing characteristics, textures, toning ability and other creative possibilities on today's papers, as a flick through the pages of this book will show. Despite the loss of Kodalith LP our creative possibilities in lith printing continue to expand.

It is important to remember the following:

1). Not all papers are suitable for lith printing.
2). Some that are not will respond – albeit very differently – to re-development in lith developer after bleaching, see Chapter 9 (Bleach and Re-development Games).
3). Image characteristics can vary greatly from one lithable paper to another and will influence your choice of paper for a particular negative. Many examples of this will follow.
4). The response of lith prints to toners and bleaches also varies from one emulsion to another – many examples will be seen throughout this book.

IMPORTANT…STOP PRESS

Emulsion Changes – Just as this book is going to press, I have heard that Kentmere are to change the emulsion they make for Kentona, Art Classic and Tapestry papers, in order to remove the cadmium it contains.

Although samples of the new emulsion are not yet available, it seems reasonable to expect that this will have a significant effect on the way these papers respond to lith printing and toning.

You are also referred to the following sections at the back of this book:

- UK/US/Australian Paper Equivalents
- Paper Speed chart
- Paper Characteristics table
- List of Suppliers

Although new emulsions are always coming onto the market – many with lithable properties, the following are the main players at the time of writing:

Sterling Premium F Lith

This is currently the only truly dedicated lith paper. A double-weight, fibre-based paper with an attractive egg-shell finish, it dries commendably flat and conveniently accepts pencil for signing.

This is the paper described in my last book *The Photographer's Master Printing Course* as Process Supplies Lith Paper – its name at that time in the UK. In normal developer it yields full tone images at about grade two (the manufacturers say grade three). In dilute lith developer it can give characteristic lith prints with good whites, cold blacks and pinky-to-yellow sepia mid-tones, according to processing.

The contrast can be varied in the processing from grade zero to grade six or seven with ease and it can yield an impressive range of results from the most delicate and soft, to the hard and graphic. It tones beautifully in gold and selenium for a range of effects described in detail later.

Manufactured by The New India Industries Ltd, in Bombay, this paper is marketed worldwide. It is prone to a controllable phenomenon known as pepper fogging – which is discussed further in Chapter 5 (Pepper Fogging, Highlight Fogging and Developer Replenishment). It is the most lithy of the papers available today.

Safelight requirement: Red.

Kentmere Kentona and Art Classic

Both lovely warm-tone papers in their own right. Kentona is a glossy, double-weight, fibre paper whilst Art Classic is a heavy, 240g, finely textured 'art' paper with a soft, ivory tone.

Both of these papers lith print well to give colours on drying ranging from soft brown, through orange, to pink, to brick red or even maroon – depending on the technique used. Although they produce a less marked lith effect than Sterling Lith, they both respond positively to gold, going through a range of mauves and purples to a strong blue, and their response to selenium is astonishing, giving the option of multicoloured prints if processed appropriately, see Chapter 8 (Toning Lith Prints).

Safelight requirements: Ilford 902, Kodak OC or red.

Fotospeed Tapestry

A warm-tone paper that responds in the same way as

Art Classic above, giving pinks and reds in dilute lith developer and impressive multicoloured images in selenium. It too responds positively to gold.

The paper is a heavy fibre-based art paper, drying fairly flat, with a much more heavily textured surface than Art Classic. Both Tapestry and Art Classic are particularly suitable for hand-colouring.

Safelight requirements: Ilford 902, Kodak OC or red.

Kodak Kodagraph Transtar TP5 Paper

This is a specialist paper with many differences to those previously described.

It is a high-contrast, projection speed, negative-working resin coated paper for making high quality positive or negative reproductions with an enlarger or process camera. It is therefore a special application paper that is likely to need special ordering. It is rather expensive and only comes in boxes of 100, at A4 and A5 sizes. The larger sizes A2 and A1, and rolls are also available.

In terms of lith printing, it is extremely easy to use, typically giving bright pinks or reds (caramel coloured when wet) and good solid blacks that separate convincingly, and swiftly, to give a good, and very controllable, lith print effect. It can also be processed to give browns and blacks.

Being a resin paper, it drip-dries flat but without having a plastic feel when dry. It dries with a marked colour shift, so don't be disappointed if you can't get a pink print in the dish – you will when it dries!

It tones enthusiastically in gold and selenium, giving the choice of subtle colour shifts or bright colours. Being resin coated, it is particularly suitable for multiple toner processes, as it requires only a brief wash between stages.

Another interesting property of this very thin paper is that it can be exposed through the back for a softer diffused effect. This is particularly suitable for soft, dreamy images. However, if blacks are required they can block up easily using this technique and sprout into dense, over-conspicuous patches unless carefully controlled. Allowing this to proceed can give a sort of pseudo-solarisation effect that might suit some images. This paper is best stored flat.

Safelight requirements: Red.

Oriental Seagull Papers G and VC

These papers work exceptionally well in lith developer producing colours very similar to Sterling

Premium F Lith, but without the pepper fogging – although they are not quite so good at the graphic end. They are also excellent general use papers.

Safelight requirements: Seagull G – yellow/green. Seagull VC – Kodak OC or Ilford 902

Forte Polywarmtone FB and Fortezo Museum

These warm-tone Hungarian papers have acquired something of a cult following for high quality black and white printing. They both also respond to the lith printing technique and in a similar fashion, albeit with significant differences.

The colours tend to range from reddish-brown to dark chocolate depending on the technique. This colour can be fairly uniform through the tonal range – particularly in darker low-key prints – but Fortezo in particular can also give beautiful and delicate pinks alongside soft browns in the mid-tone bands.

The first is a variable contrast paper with both glossy and semi-matt finishes available and comes in both fibre and RC versions. The second is a graded paper with a glossy surface. Lith prints on these papers respond well to selenium, and particularly to gold toners.

Important Note: Owing to its extended spectral sensitivity, Polywarmtone is probably the paper most susceptible of all to light fogging. Extra care with both safelighting and the use of darkroom torches is advised.

Safelight requirements: Polywarmtone FB – dark red with extra care. Fortezo Museum – orange or yellow/green.

Forte Polygrade and Bromofort

Also from the Forte house, these are two cold-tone papers capable of giving real blue/black tones in appropriate developers. It is therefore perhaps surprising that they do lith print so well. The results are quite different from their warm-tone counterparts, as the blacks are cold blacks and the mid-tones sand, beige or peach coloured according to the technique used, with Bromofort giving the colder tones of the two – sometimes approaching a sandy/grey. This can give a much more convincing typical lith effect, as lith prints on the warm-tone papers could sometimes be mistaken for toned prints.

Polygrade is a fibre-based VC paper with a glossy surface, whilst Bromofort is a fibre-based graded paper with a choice of glossy or a beautiful dead-matt surface. Fortespeed Polygrade is a resin coated version of Polygrade.

Safelight requirements: Polygrade – red. Bromofort – orange or yellow/green.

Ilford Multigrade Warmtone

This paper from Ilford is certainly a flexible paper of high quality with regard to normal printing and it is also excellent for thiocarbamide, and selenium toning.

It is also being used for lith printing – but the result achieved is different. Best results are in hot, dilute lith developer at about 40°C. Infectious development does occur with the sprouting of blacks, but the colours remain fairly restrained in comparison to the other papers here. It does however respond fairly well to toning when lith printed and particularly pleasing secrets can be unlocked with bleach, and re-development techniques.

Long, hot development in highly alkaline lith developer causes this paper to develop 'measles' – a rash of large semi-translucent spots. These are harmless and disappear on drying!

Safelight requirements: Ilford 902 (light brown) or similar.

MACO Expo series RR, RF, RN

This is a new range of papers imported from Germany and testing samples arrived just in time for inclusion in this book. These graded papers come in a range of three surfaces including a luscious deep matt. They are part of the larger MACO range and are marketed with a technical data sheet specifically written for the lith printing process.

They respond convincingly to dilute lith developer in a similar way to Forte's warm-tone papers. They are free of pepper fogging although may throw up isolated black spots on occasional sheets, as do Bromofort and Polygrade papers. They also respond well to both selenium and gold toners and are a welcome new addition to the range of lithable papers.

Safelight requirements: Red or yellow/green

Chen Fu

Imported from Taiwan. This paper lith prints well, but I am told that both availability and batch consistency are somewhat erratic.

CHOOSING THE CORRECT PAPER

It is certainly a sign of the times that I even have to consider writing about the choice of papers for lith printing. Whilst once the choice was minimal, the newcomer is now faced with what might appear to be a bewilderingly large selection from which to choose.

I think that there are five things to consider when choosing a suitable paper for a particular image;

Safelight Tip

• Safelight recommendations vary from paper to paper. Remember that although amber gives better visibility, red is a safer choice if you are uncertain.
• Extra special care should always be taken with Forte's Polywarmtone because of its extended spectral sensitivity.
• The use of safelight torches should be kept to a minimum and largely restricted to the period immediately leading up to snatch-point when they are most useful.

1). Emulsion Characteristics – Lith prints on different papers do not look the same.

Sterling Premium F Lith paper will give the most lithy results and can give very graphic effects as well as soft and delicate ones. It offers a large contrast range and will give a black, a white and in between a variable pink or yellow-beige coloured mid-tone that stands apart from either.

Bromofort and Polygrade give a similar, but not identical, tonal colour separation effect to Sterling Premium F Lith.

MACO Expo series RR, RF, RN and Forte's Polywarmtone FB and Fortezo Museum tend to give a much more uniform colour across the tonal range with a warmer reddish-brown in the mid-tones between a brown-black and the white – although Fortezo can also give wonderful pinks.

Kentona, Art Classic, Tapestry and Transtar TP5 all tend to give pink or red prints (variations from this are possible and are described later). They may look less lithy, but can have very different responses to toning.

2). Response to Toners – Lith prints on all of these papers are capable of great colour changes in gold and selenium toners. This can be very important for some images and may indeed be the reason that the lith printing process was chosen in the first place. Whereas they will all produce purples and blues in gold, the multicolour effect in selenium of Kentona, Art Classic and Tapestry cannot be obtained on the other papers and may often be the sole reason for choosing one of these three for a particular picture.

3). Surface Characteristics – If a textured art paper surface is required, the choice of paper is either Art Classic or Tapestry, the latter being the more heavily textured of the two.

If a deep matt surface is preferred, the choice must be either MACO Expo RN or Bromofort. Transtar TP5 also offers a matt finish but is not as dead-matt as the other two. Sterling Premium F Lith paper has an attractive eggshell finish described as semi-matt.

Some of these papers can also come with glossy, stipple or satin finishes (see the Paper Characteristics table on page 111).

It is of course possible to render a glossy print matt, or a matt print glossy, by spraying the print with a matt or glossy spray varnish after processing and drying. These can be very effective and help to make your choice even wider.

Glossy and matt print sprays are available and expand your choice of emulsion/surface characteristics combinations. They also protect hand-colouring and make invisible the tell tale signs of spotting, and other after work.

4). Resin Coated vs. Fibre-Based – There are three lithable papers now available in resin coated paper – Transtar TP5, Fortespeed Polygrade and Polywarmtone RC. If you want the easy washing properties of RC papers, these are for you and between them offer a good spectrum of the other lith characteristics.

5. Universality – If making only occasional lith prints, it is useful to have papers that serve both purposes and give high quality results with conventional printing but can be lithed as well when required – thus avoiding the need to make a special purchase. The main players here would, in my view, be the Forte, Oriental, MACO and Kentmere ranges.

CHEMICALS

• Lith Developer
A lith developer is essential. All come in two parts usually referred to unambiguously as A and B, with long storage properties until mixed for use. Most are liquid concentrates although some are in powder form.

Mixing instructions normally apply to use with lith film, in which case further dilution is required for lith printing. Fotospeed's LD 20 Lith developer now carries additional instructions for lith printing as well as additives to control pepper fogging. The new MACOlith also carries instructions for lith printing. There is one exception to the above – the new kid on the block, Speedibrew's Litho-print, that is a single solution and is formulated specially for prints.

Kodalith liquid concentrate developer
Ten litres (5A + 5B) of concentrate make 40 litres of film strength solution. In this quantity this excellent developer may be too expensive for the low volume user, although it will keep for years unmixed.

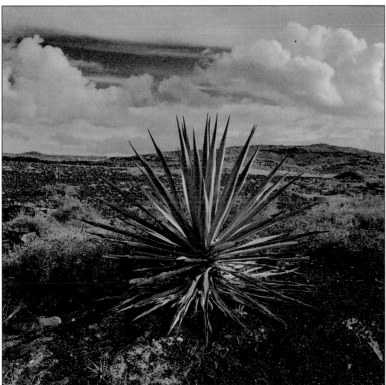

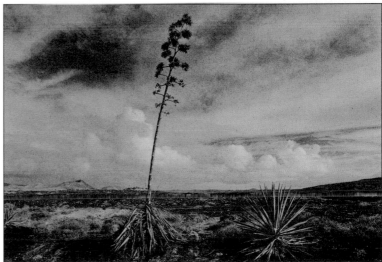

"A footnote in photographic history" – the paper that started it all. Kodalith LP paper had wonderful tones with deep blacks, clean whites and a characteristic warm colour. It was flexible in the printing and had a richness that set it apart from other papers.

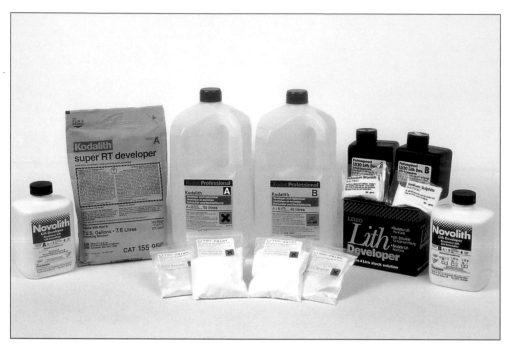

The main lith developers available in the UK. The new MACOlith arrived too late for these product shots, but has been tested with good results.

Kodalith Super RT developer

This comes in powder form – A and B – to give 7.6 litres of film strength developer for about a quarter of the price of Kodalith liquid. It is not simply a powder version of Kodalith concentrate. In particular, part B contains no caustic element, as does the concentrate, and it is less likely to throw down a precipitate in hard water areas.

Champion Novolith Developer

A liquid concentrate, 1 litre of A + 1 litre of B giving eight litres of film strength solution. Five litre sizes are also available.

Fotospeed LD 20 Lith Developer

A liquid concentrate in 500ml quantities each of A and B giving 4 litres of film strength solution. This developer is currently the only one to include comprehensive instructions, specifically for lith printing, as well as separate additives to control pepper fogging on Sterling Lith paper.

MACOlith liquid concentrate developer. In the USA: Cachet/fappco 2 part developer 690

This new lith developer is marketed with MACO papers. Unconventionally it comes in A and B solutions of unequal volume – 1 litre A and $\frac{1}{2}$ litre B. Mixing instructions are in corresponding ratios.

Instructions are given specifically for lith printing rather than for film use. They warn that its vapours can cause eye or nose irritation at temperatures above 25°C, unless used in a well ventilated darkroom. I have not found this to be a problem – but all darkrooms should be well ventilated as a matter of routine.

Speedibrew Litho-print developer

This new product is not in fact a true lith developer and it comes in a mix-in-the-bag powder kit to make a single solution, unlike all the lith developers mentioned above.

It has been developed by Michael Maunder specifically to give colour effects on suitable lith-type papers without the problem of pepper fogging. I have tested the prototypes and the final version of this developer, and it does both of these things, but requires a slightly different technique to get the best results. I return to this product in Chapter 8 (Toning Lith Prints).

Doculith (Tetenal)

Despite its name this is not so suitable for lith printing, in that it is based on potassium hydroxide and does not give true infectious development. However, the adding of the powerful alkalies sodium or potassium hydroxide to a developer such as PQ Universal can produce colours, said by some, to be similar to a lith print, but here any similarity ends. This technique is considered further in Chapter 10 (Lith Look-a-Likes).

• Stop Bath

This is essential, as development in the dark tones is accelerating fast and must be halted swiftly at the desired moment. If streaking flow patterns appear on the print, it may be that the stop bath is too strong and a little extra water cures the problem. Oriental Seagull was prone to this, but with emulsions always changing, the phenomenon could conceivably occur with other papers in the future.

• Fixer

Either acid or alkali fixers are suitable and should be carefully controlled, using the shortest fixing time, as over-bleaching may bleach out some of the subtle highlight tones. This is even more important than in conventional printing, because the very fine grain structure of these early-stage-of-development highlights makes them extra vulnerable to fixer bleaching – see fix-up in Chapter 3 (Making a Basic Lith Print). You should also be aware that higher key lith prints will work your fixer extra hard, so be prepared to replace it more frequently.

• Kits

Fotospeed produce a Lith Printing Starter Pack containing 10" x 8" Sterling Premium F Lith paper (not normally available in this size), LD 20 lith developer and anti-pepper fogging additives. These kits also include instructions for lith printing.

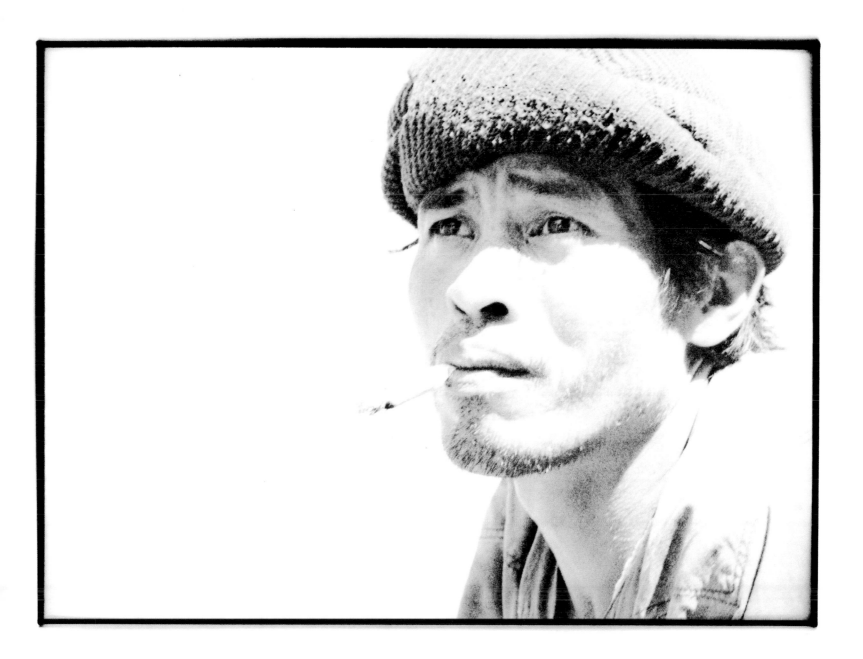

Chapter 3
Making a Basic Lith Print

The first thing to realise is that many of the rules of good conventional printing, so carefully learned to date, no longer apply in lith printing. The new rules are not at all difficult, although unlearning how to print can, for some, be almost as difficult as learning how to print!

In essence, the paper is heavily over-exposed, slowly developed in highly dilute lith developer and snatched before completion, with contrast, colour and grain size all being controlled by the processing technique. In practice each of these stages sounds deceptively simple but contain pitfalls for the uninitiated. Even burning-in, dodging and flashing need a little extra consideration.

BASIC PROCEDURE

• Developer Preparation

The lith effect varies both with the dilution and maturity of the developer. Greater dilution can aid more separation between warm and cold tones, as well as soft and hard contrast. It also extends developing times and reduces developer capacity per unit volume and so a balance may need to be struck. Higher temperatures can be used to shorten development times, but this in itself can affect the result.

I quite often use high dilutions and 20+ minute developments for delicate prints, so a comfortable chair and CD player are useful. I aim for six to ten minute development times on workshops for obvious practical reasons, and the results are perfectly satisfactory. At high dilutions the amount of active developer in the tray is small and development may fail suddenly in the middle of a print – so it is sensible to always have fresh developer for replenishment already measured out and standing by.

A good starting point would be three times the dilution given in the instructions for film use. Most liquid concentrates recommend for films a dilution of 1 + 3 with water. This means 1 A + 3 water plus 1 B + 3 water – not 1 A + 1 B + 3 water. For prints start therefore at around 1 A + 1 B + 18 water for acceptable development times and experiment upwards as far as your patience permits.

NOTE: Kodalith Super RT is NOT a liquid concentrate. It is a powder product. The liquid concentrates are approximately three times stronger than the made up Super RT liquid that is used at 1A + 1B for film use. So for this developer start at 1A + 1B + 6 water.

I generally use 100 ml A + 100 ml B liquid concentrate in anything from $2\frac{1}{2}$ to 5 litres in a 20" x 16" tray. More than 5 litres gets messy. Much less than 100 ml of A + B in the dish gives a very limited working capacity. This not only increases the risk of development failure in mid-print, but reduces the consistency of results as the developer matures, so increasing dilution should not be achieved at the expense of too much concentrate reduction – unless using it as a one or two shot process.

Old Brown – Fresh developer gives the least interesting results in lith printing. As the developer is worked, the colours and the lith effect become stronger – see the Peeling Poster series that demonstrates this (see opposite). For this reason I always add to my fresh developer some well oxidised lith developer – Old Brown – left out from a previous printing session and rebottled for this purpose.

The amount of Old Brown used is an inexact science. It depends on the dilution of the original Old Brown and how hard it has been worked or replenished. It may also depend on additives used to control pepper fogging. This will be covered in more detail in Chapter 6 (Lith Printing Advanced Class).

It depends too on which developer is being used, for they are not all the same. Champion and Fotospeed developers mature more slowly than Kodalith but have a much longer period of activity before needing replenishment or replacement.

I usually add about 100ml of Old Brown to 100 A + 100 B concentrate, less if I am using the weaker Super RT solutions. I also vary this according to how hard worked the Old Brown was, and on which paper I am printing – for example, the Poster Series shows that Kentona has a particularly small optimum-effect-colour-window before fogging occurs. Too much Old Brown may take you past that point. Some lith printers prefer

the crisper, colder effect obtained in fresh developer and replace it after two or three prints for consistency. It is all subjective.

• **Determining Exposure**

There are three ways of doing this;

1). Test Strips – Although some advocate using test strips to determine exposure, they are difficult and unreliable in practice. The problem arises because development is always incomplete in lith printing. The whole strip must be snatched when the desired end point is judged to have been reached – but that end point will come at a different time in each strip, as both the emergence of the black and the development time is directly related to the amount of exposure given – catch 22! (see page 34).

2). Test Pieces – A more reliable method is to give increasing exposures as with a test strip, but to a series of separate small sheets exposed to the same (and the most important) part of the negative. These can be processed together and pulled from the developer one by one as the snatch-point is reached on each one. Exposure is much less critical than in conventional printing and increments of $\frac{1}{2}$ a stop give a useful guide. Use $\frac{1}{4}$ stop adjustments for finer tuning (see page 35).

3). The Quick 'n' Easy Way – The easiest, most economical on paper and definitely the fastest method however is to make a standard test strip on the paper to be used and develop it fully in standard print developer. Select an approximately correct exposure from this – using the highlights or mid-tones, <u>not</u> the shadows – and

Nine sheets of 12" x 16" Kentmere Kentona paper were given identical straight exposures and processed one at a time in two litres of freshly prepared Kodalith concentrate diluted at 1A + 1B + 18 water without additives or replenishment.

The four examples here are print numbers 1, 5, 7 and 9 in the series (from left to right starting at the top) and illustrate the slow build-up to optimum effect in print 5, followed by the rapid fall-off in print quality already obvious only two prints later in print 7. Print 9 was barely processable.

This is typical of this paper/developer combination. However print colour can be varied between pink, orange and maroon. The slow start up phase can be shortened by adding Old Brown and the short optimum-effect-window can be extended by additives and replenishment. These techniques will be described later in the text.

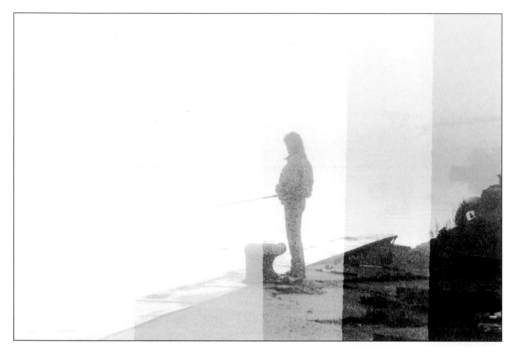

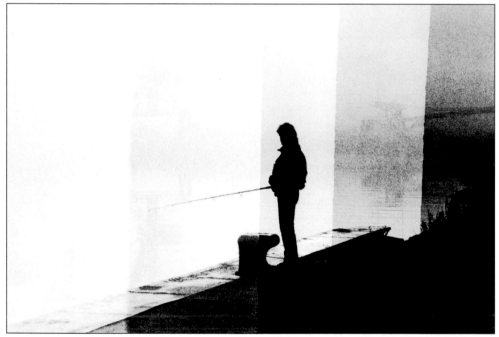

Although test strips can be used to determine the exposure for a lith print they can be misleading and hard to interpret. As the blacks are controlled by the time in the developer and the light tones by exposure, snatching the same test strip at different times – as shown here – will give very different results in all but the light tones.

add two stops for the lith printing exposure. Although this involves making up an extra solution, you have an approximate answer in two minutes.

• Making a Print

Exposure times are less critical than in conventional print making, but over exposure of two or three stops makes them very long. For example, an exposure time of 20 seconds now becomes 80 or 160 seconds respectively.

Having exposed the paper, slide it into the developer, select your favourite CD and settle down to wait. Development in relative terms is even longer and if you are used to the near instant reaction of resin-coated papers, you may begin to wonder if you exposed the right side of the paper! After several minutes, a faint ghost image will appear. Agitate gently and continuously and, assuming you want a black tone in the print, wait for the darker tones to slowly reveal themselves. Resist the temptation to leave the print unattended whilst you do something else.

Snatch-point – Ignore the emerging light tones. Judgement at this stage can be difficult. The fine grained light tones are barely visible under red or amber safe lights. Old Brown and maturing developer obscure them further. In addition, some papers develop what looks like a milky film over the image, that only clears in the fix to reveal what you could not see in the developer. Used intermittently and cautiously, a safelight torch is invaluable here. Confine your attention to the area of the most important dark tone in the picture and scrutinise carefully. Lifting the print out of the (usually brown) developer for inspection often helps.

Eventually small black areas form in the dark tones and start to coalesce, initially slowly, then with increasing speed – the clearly visible process of infectious development (see page 36). Having waited 10 or 20 minutes for this point, you now have seconds to slide the paper into the stop bath. Don't hold the print up to drain or you will lose what you have waited for!

CAUTION – Development in lith printing is slow. The development of light tones especially so. It is partly for this reason that safelight torches used near snatch-point are fairly safe – it might take another five minutes for the fogging to be developed, whereas the print will be snatched in one or two minutes – before the fogging can occur.

Indeed, it may be possible to momentarily flick on the lights to check progress just before snatch-point and still get the print safely in the stop bath before fogging becomes evident. (I am not saying I advise this, only that it is possible – providing you do not mis-time it!)

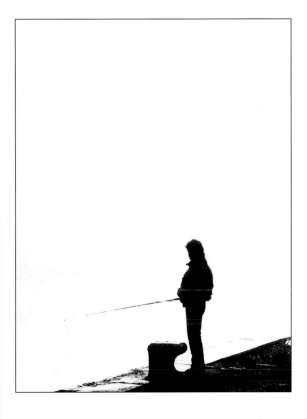

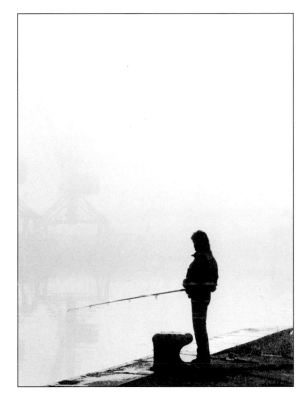

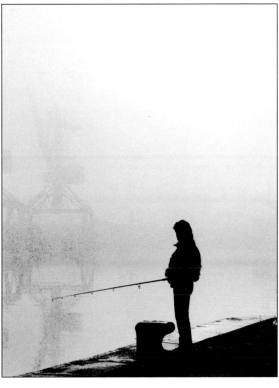

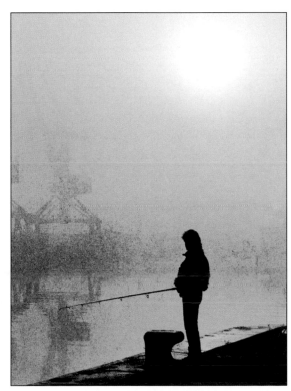

It is more useful to use separate test pieces exposed to the same part of the negative. The exposure may be varied in $^1/_4$ or $^1/_2$ stop increments and each piece pulled from the developer when the crucial blacks reach the required stage in development. Comparison after dry-down is easy and meaningful. Note that the light tones are controlled by exposure.

TIP: *To save time, these test pieces can be dried in the microwave.*

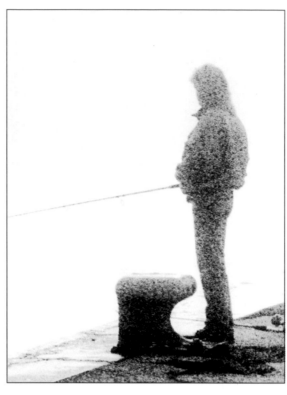

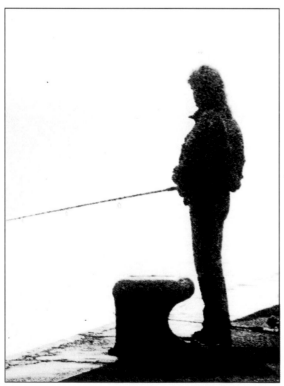

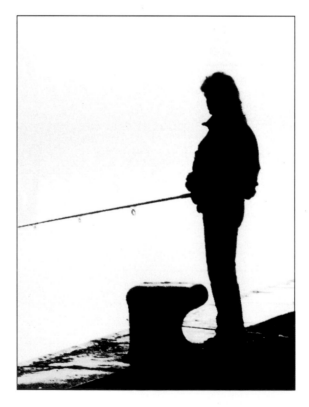

Infectious development. These four identically exposed pieces show the progress of infectious development exactly as you will see it happening in the dish, particularly with Sterling Premium F Lith paper. Progress can be stopped at any time by transferring the print to the stop bath.

Note that only the shadow tones are controlled by development. There is little change in the light tones here as development is allowed to proceed.

Use of the safelight torch should therefore be resisted until development is close to the snatch-point. There is simply no point in using it earlier – it tells you nothing and increases the risk of fogging being developed during the remaining development time. I do see workshop attendees examining blank pieces of paper in the developer with their torches, looking for the first signs of the image – this is pointless. A safelight torch is only helpful in accurately pinpointing the moment to terminate development.

• Dry-down vs. Fix-up

Bruce Barnbaum used the phrase wet-up to describe the opposite of dry-down – the lightening of a print when it is wetted – and it was this that prompted me to coin the term fix-up for what happens next.

Fixing should always be for the shortest possible time. Delicate highlights are always at risk of being bleached by over-fixing, and in lith prints the highlight tones are much more delicate than usual, having been stopped in the early stages of development when their grain size is exceptionally small – in the form of delicate filamentous grains. These will always be etched back to some degree by the fixer.

You may not, however, be prepared for the sudden and at times dramatic degree of lightening that occurs when the print is transferred to the fixer. I call this fix-up.

To make matters worse, this may (it depends on the paper and the tones in the image) be accompanied by an alarming apparent leap in contrast – very frustrating after the long gestation period to get it just right up to this point. This is also another good reason not to judge progress in the developer by the light tones – the only exception to this being a soft or high-key print with no blacks.

Fortunately, switching on the light reveals colours that were invisible under the safelights – and after dry-down you will usually get back what you expected.

• A myth exposed

If you switch on the light when the print is in the stop bath and then transfer it to the fix, the myth of fix-up is exposed.

Although some fixer bleaching does occur, most of the alarming fix-up phenomenon is actually due to the print changing colour from a blue or lilac to pink or beige. The tones are still there – the new colour is simply rendered invisible under the safelight of the same colour. This means that you may only see blacks and near blacks – and white.

The phenomenon of fix-up. This series of three flash-lit pictures shows Kentmere's Kentona paper fixing-up as you would not normally see it under safelight conditions. The first was taken in the developer dish and shows the purple tones that are easily visible under the amber safelighting recommended for this paper. The second picture shows the paper fixing-up in the fixer tray and the third shows the fully fixed print. The change in colour from purple to an amber, that closely matches the safelight, is responsible for the illusion of fix-up, where the mid and light tones suddenly become invisible – until the room light is switched on.

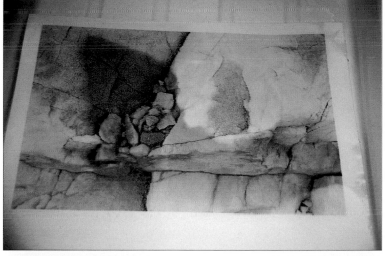

Sterling Premium F Lith paper.

Fotospeed Tapestry paper.

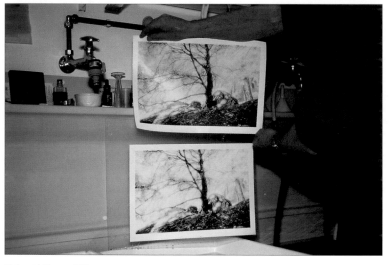

Kodagraph Transtar TP5 paper.

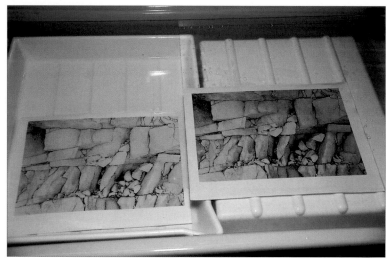

Kentmere Kentona paper.

Dry-down may be associated with a significant colour change in lith printing, but this varies according to the paper in use. As shown here, Sterling Premium F Lith paper dries down with only minor colour changes compared with the very warm emulsions of Kentmere's Kentona and Art Classic, and Fotospeed's Tapestry. These latter papers all change from browns towards reds during drying, although the final colour is determined by the processing techniques. Kodagraph Transtar TP5 shows a marked colour shift from caramel when wet, to bright pink when dry.

Hence the apparent but fallacious impression of a great jump in contrast.

Wash the print thoroughly, preferably using a hypo-clearing agent to remove all traces of fixer. This is important if subsequent bleach techniques are planned.

• Colour-down

Dry-down takes on a whole new meaning with many lith papers. Having watched the colours change during fix-up, you will now see them change again during colour-down as they dry!

This is particularly so with Kentona, Art Classic, Tapestry and Transtar TP5 * all of which change from shades of caramel or beige to pink or red.

So now you have your final lith print colours. Or do you? The reality is that you are only just starting. You can have them as they are now, or change them to a whole range of colourful alternatives – but that's another chapter.

*Overseas readers are reminded to check the US/UK/Australian paper equivalents on page 124.

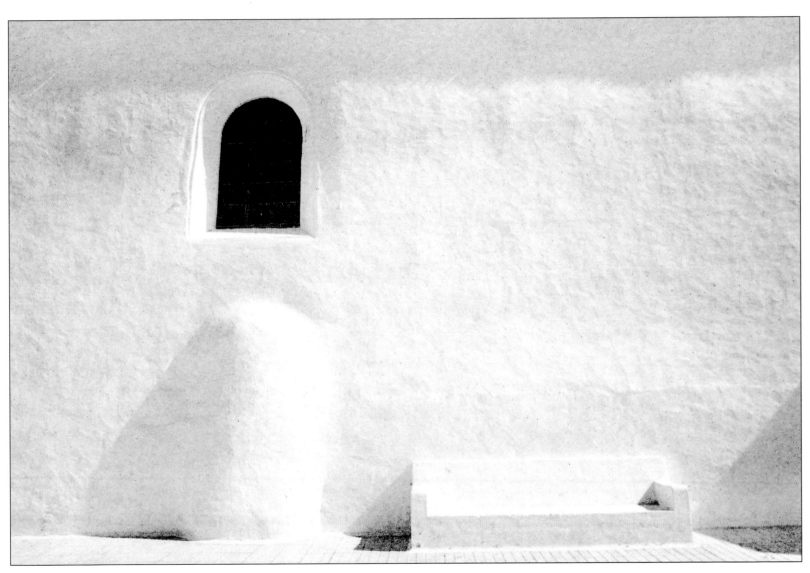

The above print was made on MACO Expo RF paper developed in MACOlith developer.
This paper produces slightly pinkier tones than Sterling Premium F Lith which it
otherwise resembles. It is however free of pepper fogging.

Taking Control of the Process

In this Chapter:

- *The Golden Rules of lith printing*
- *Varying snatch point*
- *Contrast control*
- *Special considerations – burning-in, flashing, dodging*

Most darkroom workers tend to be interested in two aspects of any process. Firstly, how to control it for predictable and reproducible results. Secondly, how to exploit it and push out the boundaries for greater creative expression. Lith printing should both appeal to and challenge such people.

So far we have looked at;
- **The materials** required for lith printing
- **The concept** of exploiting infectious development to produce a typical lith print
- **The process** of making a basic lith print

As satisfying as it may be to see your first lith print emerge from the dish – this really is only the beginning of the creative options of lith printing.

Lith printing has a reputation for being impossible to duplicate and difficult to control. I plan to show you that if you understand the very simple fundamentals involved and are consistent, and disciplined, in your routine – just like all darkroom work – you can quickly take control of this process and, within limits, reproduce results fairly consistently.

You will then be ready to exploit its considerable creative potential with confidence.

• Taking Control

At the heart of lith printing is the phenomenon of infectious development – this is peculiar to lith developers. Kodak described infectious development in terms of lith developers used on Graphic Arts lith film for dot and line work as follows;

"These developers all work on the principle of infectious development, i.e., an increase in the *size* of the image (remember this is dot and line work) as development proceeds".

They illustrated this by showing black on white dots and grids expanding with development.

In terms of lith printing, however, what we see is an exponential increase in the *rate* of development in the dark tones as they get darker. If you watch closely you will see that when the dark areas (e.g. shadows) reach a certain depth of tone, they will sprout tiny black dots within that dark area. These dots will rapidly increase in size and eventually coalesce to form solid black – unless you snatch the print and stop development beforehand.

So what we observe is both an increase in the size of the paper emulsion grains and the speed at which they continue to develop.

The combination of these two gives a sudden rush at this point and you must be ready to move quickly when the result reaches the appearance you want – this is your snatch-point and sometimes it will pass you by in seconds! The remaining tones are still light and consequently developing slowly, and are therefore lagging way behind when you stop development at your chosen snatch-point.

Remember – The large (shadow) grains are;
- Dark
- Cold in tone
- High in contrast
- Coarse in appearance

The small (highlight) grains are;
- Light
- Warm in tone
- Low in contrast
- Smooth in appearance

This gives the classical black/colour/white split and the typical hard in the shadows/soft in the highlights qualities of a lith print.

However;

Exactly what proportions of each you choose to have is affected by your snatch-point and can greatly alter the appearance and mood of the image as we shall see later – but it is under your control.

The key to controlling the whole process can be summed up in my two Golden Rules. Learn them and pin them on your darkroom wall, for they are the key to the Holy Grail in lith printing.

> The reader is referred to the Lith Printing Troubleshooting Guide on page 110.

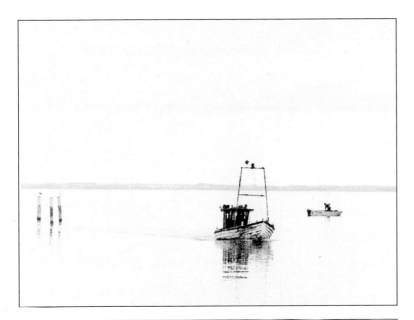

These four Sterling Lith prints come from a larger series of twenty two showing the effect of increasing exposure in $^1/_4$ stop increments – in this case from seven seconds to 4 $^1/_2$ minutes. Time spent experimenting with exposures and snatch-points is time well spent. It reveals to you the interpretative possibilities of the materials.

The four pictures selected have a difference of $^3/_4$ of a stop between each print, the snatch-point in each case has been the emergence of blacks on the main boat. The second and third prints (top right and bottom left) show the anticipated drop in contrast as density builds up in the lighter tones of the sea and sky. By the fourth print (bottom right) the mood is changing towards a low-key print, as the shoreline and related tones approach those in the boat. Had the snatch-point been selected to keep the shoreline tones constant, a different set of pictures would have resulted.

It is helpful to experiment with the various controlling factors in lith printing in order to know their effects and how to apply them judiciously.

This series of nine pictures demonstrates some of the effects of delaying snatch-point (down) and increasing exposure (across). All prints are on Sterling Lith paper and the exposures for the three vertical columns were: first, seven seconds at f4; second, + 3³/₄ stops at 1 min 35 seconds at f4; and finally third, + 5¹/₄ stops at 4 mins 27 seconds at f4. It is not uncommon to have 5 or 6 stops of useable contrast with this paper, depending on the negative in use. The permutations using just these two variables are considerable, allowing a fine degree of control.

When snatch-point here is set at the emergence of the blacks in the boat, the sky tones are creamy and grainless. Clouds are hinted at and the scene is light and airy.

As snatch-point is delayed, more tones progress towards black, changing the image colour and the mood of the scene.

Eventually even previously light delicate tones in the sky darken ominously with pronounced grain, suggesting low evening light. The appearances begin to resemble some of the earlier or alternative printing methods.

Delaying snatch-point therefore has a profound effect on the picture and on how it communicates. This effect varies with different types of images.

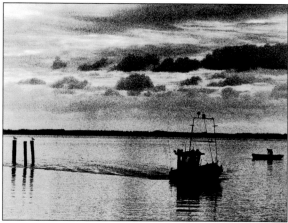

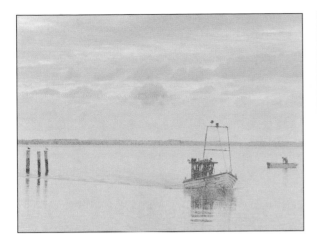

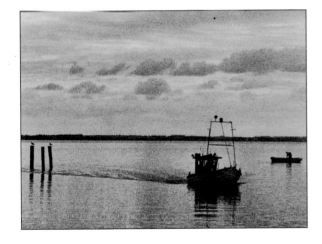

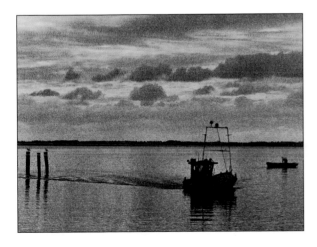

APPLYING THE GOLDEN RULES

Exposure under the enlarger is what determines absolutely, and selectively, the density of the lighter values in lith printing. If the print has insufficient tone in the lighter areas, simply increase the exposure by $1/4$ to $1/2$ stop in the next print.

You cannot darken light tones alone by extending development. This would only significantly change the amount of dark tones, for these develop infinitely faster than the lighter tones as a result of infectious development. In fact, if you look at the series of illustrations on page 36, showing the progress of shadow detail with infectious development, you will see that the lighter tones behind the figure do not significantly alter during this period of development at all.

Similarly, if the lighter values are too dark, reduce exposure in the next print. An adjustment of a $1/4$ of a stop will have less effect than you are used to seeing in your normal print making.

Development determines the shadow detail. It is affected by various factors such as developer type, dilution and temperature, but most of all by your choice of snatch-point and it is worth considering this now in more detail.

• Snatch-Point

The factor producing the most dramatic effect on the appearance of the untoned lith print is the choice of snatch-point, when the print is snatched from the developer and development is halted in the stop bath.

The choice of snatch-point is usually – but not always – when the most important shadow area has reached the required density. Because the paper has been heavily over exposed, it is never allowed to develop to finality and the correct snatch-point is an entirely subjective decision. If snatch-point is delayed, the chosen shadow areas will block up and the next darkest tones will take on the characteristics of fully developed shadow areas, changing their fine grained, warm coloured, delicate appearance to a larger grained, colder coloured, coarser one.

Some negatives can yield acceptable and pleasing alternatives of radically different appearance and if you do not experiment with different snatch-points, you will never know what might have been possible.

On my lith printing workshops I often encourage novice lith printers to identically expose three prints and develop them together, pulling the first at what they believe to be the right moment and leaving the others to progress to more advanced stages of development in order to see what happens. I would encourage you to do this. It shows you what is possible and even if the colder image does not suit that negative, it may well suit another you had not thought of, either in terms of lith printing, or with that interpretation.

The rejects also provide useful experimental material to see the effects of larger grain size in bleaches and toners. After all you can only pre-visualise a finished print, if you know how the materials behave under different conditions and what options are open to you. Only consign them to the Learning Bin when you have extracted the maximum learning from them!

In the series of pictures on pages 42 and 43 the *vertical* columns show the effect of progressively delaying the snatch-point without altering the exposure.

The early snatches show a typical lith print on Sterling Premium F Lith paper with a few cold blacks, warm mid-tones and the soft creamy light tones. The later snatches give a different mood entirely, as the clouds pick up tones and the scene becomes progressively lower key, taking on something of the feeling of evening and the appearance of an old style print.

The accompanying two series show the same exercise repeated but using different basic exposures.

Changing other variables as well would give you a wide range of options. The obvious ones are exposure, developer strength, developer maturity, developer temperature, paper type and image colour through the use of bleaches as well as toners. We will examine all of these later in this book.

You may also pull back your snatch-point to take your print from the developer before any blacks appear. This pre-black snatching can give wonderfully delicate tones in suitable high-key pictures due to the small grain size.

The Trees in Mist series on page 45 give a glimpse of the degree of control you have. Unfortunately, the softer tones will inevitably suffer in the reproduction here.

• **Grain**
Grain can be either desirable or undesirable in a picture. Some photographers go to great lengths to minimise it, others adapt technique to emphasise it. Both approaches can produce impressive results in suitable images.

Lith printing can be used either to further suppress grain or to make a feature of it. Increasing exposure to provide sufficient density and curtailing development – particularly in highly diluted developer – can produce virtually grain-free highlights and mid-tones with a lovely creamy consistency. Even grainy films like Kodak High Speed black & white infrared film can be printed for grainless results (except in the shadows).

On the other hand, extending development will easily develop up the grain structure, allowing it to be heavily featured to the desired extent. The two prints of a wild Aloe Vera on page 14 illustrate the point.

• **Contrast Control**
Contrast in lith printing is determined entirely by the processing and is a function of exposure vs. development irrespective of the grade of paper used.

Sterling Premium F Lith paper carries no nominal grade and although it prints to about grade two in normal developer, it can yield anything from grade zero to grade six or more in lith. Although not all papers can quite match this, all are very flexible in lith developer.

Contrast is increased by cutting exposure and extending development and is reduced by giving greater exposure but shorter development.

Key point – In either case the snatch-point is the same i.e., when the critical point of development is reached in the selected dark tones. The effect is not the same as lengthening or shortening the development by changing the snatch-point as described earlier.

Extending development by delaying the snatch-point results in darker mid-tones. Extended development as a result of reduced exposure allows choice of blacks but with lighter mid-tones (see the Golden Rules opposite), thus giving higher contrast. As with all things in lith control it is entirely logical, if you apply these Golden Rules.

It is important to get to know the properties and limitations of all your papers so that you know in advance of a printing session exactly what they can and cannot do for you. With this in mind, try the following exercise;

1). Make an average exposure lith print on Sterling Lith paper. Half a 16" x 12" (=8" x 12") or quartered 20" x 16" (=8" x 10") would be convenient sizes for this

exercise using a 20" x 16" tray. This will be around 2 or 2¹/₂ stops over exposed as described in Chapter 2 (Equipment and Materials).

2). Then expose three similar sheets at minus one, minus two and minus three stops from the average print you have made.

3). Expose a further three sheets at plus one, plus two and plus three stops from the average print.

4). It should now be easy to develop all seven of these together comfortably in a 20" x 16" tray, as long as they are kept moving.

Because of the different exposures given, development times to the same snatch-point will be staggered and this makes control easy without rushing too much.

The last prints out may need very long development indeed, depending on the dilution and temperature. You will now have a series of seven prints showing a wide range in contrast. If you have not reached the limits offered by the negative in use, extend the series further to see just how far you can go.

If you have the patience, you might like to repeat the exercise with other papers or in stronger, weaker, hotter, fresher and older developer solutions. You will use a lot of paper, but you will learn a lot and this will save both paper, and time, later.

Using a waterproof pen, always number the prints on the back before they go in the developer and keep written notes relating to each number for future reference.

Development times can be very long for high contrast prints – some lith printers combine this with hot development to get the results they want and keep the times manageable.

Exposure times can be very long for low contrast prints. For example, a 20 second exposure for a negative for normal print developer will become 80 seconds if increased by two stops for a lith print. If this is increased a further two stops for a low contrast print, it will become 320 seconds if the same aperture is used.

You now know why I regard my CD player as an essential piece of lith printing kit!

• Other Exposure Controls

As with conventional printing, the usual time honoured exposure controls may be employed in lith printing – but there are some differences of which you should be aware.

Burning-in: This is much less often necessary than in conventional printing, as the considerable over exposure

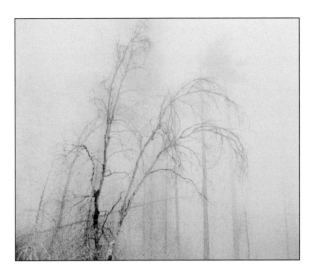

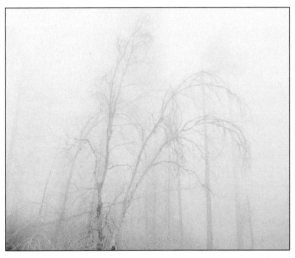

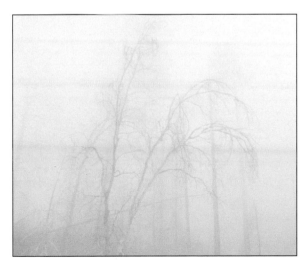

This small series of untoned Sterling Lith prints shows the effect of pulling the snatch-point back before the emergence of the blacks. Prints with only little or even no black can be very gentle and atmospheric, as they are composed entirely of the creamy grainless tones of early development. Even grainy films can sometimes give almost grain-free high value tones in lith printing. Gentle toning may further enhance the poetic or romantic interpretations of printing this way.

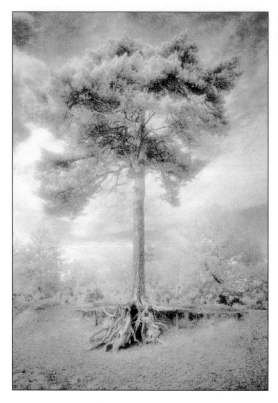
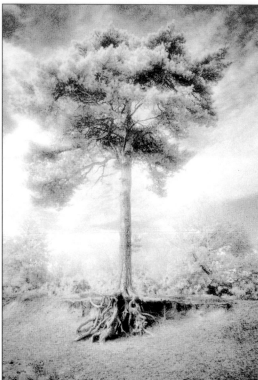
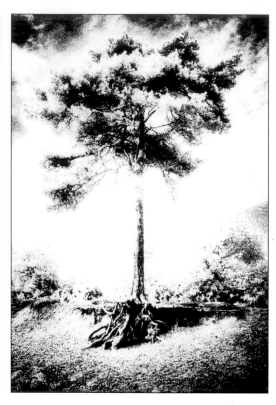

Contrast is controlled wholly in the processing in lith printing (see text), regardless of the nominal grade of the paper in use. Sterling Lith paper will yield a contrast range from grade 0 to 6 or 7. Contrast is increased by reducing exposure and consequently lengthening development to reach the required emergence of blacks (snatch-point), and is reduced by increasing exposure and thus shortening the time development takes to reach the same snatch-point.
NOTE: *This is not the same as lengthening or shortening development without changing exposure i.e., developing to a different snatch-point.*

already given ensures sufficient density to most areas. When still required however, stubborn areas may need a much greater percentage of extra exposure than one would expect in a conventional print. This can be very long. Two stops burning-in on a two minute exposure becomes eight minutes – a long time to hold your hands in place! In cases such as this, I would deliver the extra exposure in quarter or half stop increments with rest breaks in between.

Flashing: As with conventional printing, flashing can be very useful both to pull in stubborn highlight detail and to help control contrast. In lith printing it may also have subtle effects on colour.

As full development is never allowed and the paper is heavily over exposed, a conventional flash test strip is of no value. Flashing is therefore a matter of trial and error, and experience.

It is very easy to get flat prints this way, but often this is not apparent until after dry-down. As with conventional printing, flashing may be to the whole print or just to local areas.

As stated under the safelight testing instructions on page 22, it is especially important to ensure safelight safety if flashing is to be used, in case your safelighting is already affecting your paper's inertia phase.

Dodging: Interestingly, this can have two uses in lith printing. Firstly, it can be used to hold back secondary shadow areas, in order to ensure that these areas are complete at the same time as the area for which you are snatching.

Secondly, dodging may be used to keep an area free of blacks for the sake of compositional balance. This effectively prolongs the development time that will be required for the blacks to begin sprouting, until after the print has been safely transferred to the stop bath or fixer. The two pictures of the woodland scene illustrate this point.

• **Further practical considerations**

Burning-in – reciprocal effects: Because of the relationship between exposure time and contrast, and between development time, grain size and image colour,

lith printing is a dynamic where anything you do in the way of localised control may have an impact on some other aspect of the print.

For example, burning-in may cause a reduction in the local contrast. This is predictable when you consider contrast control as described earlier in this chapter. In practice, it is not always a problem, particularly where even tones are burned-in, as with a plain sky, and mostly occurs where similar mid-tones are closely placed in the print.

Paradoxically, burning-in may also occasionally raise local contrast. This happens where a dark mid-tone is surrounded by a light tone. The extra exposure may cause the dark tones to accelerate into black because of infectious development, whilst the light tones remain little affected. This is the counterpart of dodging to avoid blacks as described earlier.

Selective development: This is a commonly used printing procedure, where one part of the print is held in developer longer than the rest, or developer is applied locally to an area of the print. This is sometimes used in association with water bathing for example.

This technique can be particularly useful in lith printing in order to advance or retard the progression of dark tones towards black. Care should be taken however, for if the mid-tones are also advanced, it is the equivalent of delaying the snatch-point locally. This can give an increase in emulsion grain size in the treated part of the print. Along with this will occur a colour shift towards cold tones and large grain characteristics. It is a useful technique but should be exercised with consideration of these points.

These then are all the essential basic printing controls that you will need to make the process work for you. Interpretation of the print begins here – but will also involve many other techniques that will be covered in future chapters.

Remember!
The Golden Rules of Lith Printing

1). Image colour and contrast are related to grain size in the paper emulsion – which in turn is related to its stage of development.

2). Highlights are controlled by exposure. Shadows are controlled by development.

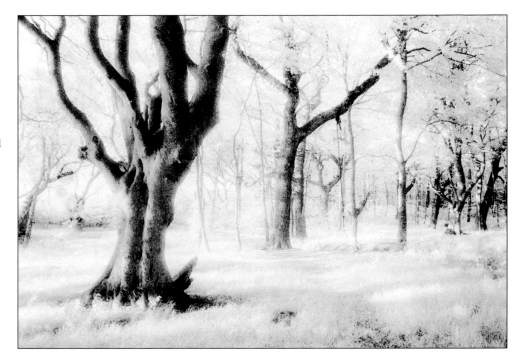

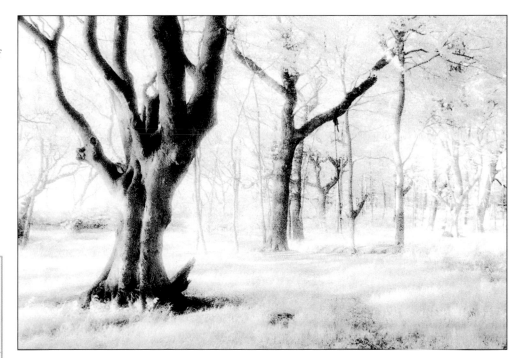

Dodging can be used for compositional balance as well as the more usual reason of tone control. Because of the rapid terminal rush in infectious development, blacks can be dodged in order to retard their development until the print is safely in the stop bath. Removal of blacks by dodging, as in the trees on the right hand side of this woodland scene, can be a useful compositional ploy which is not usually possible in conventional printing.

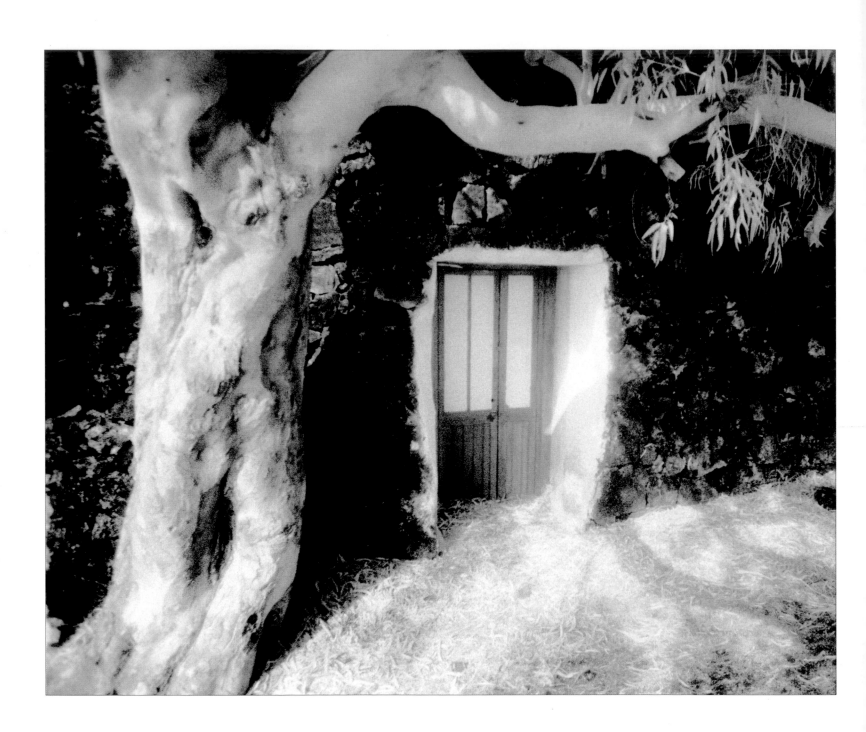

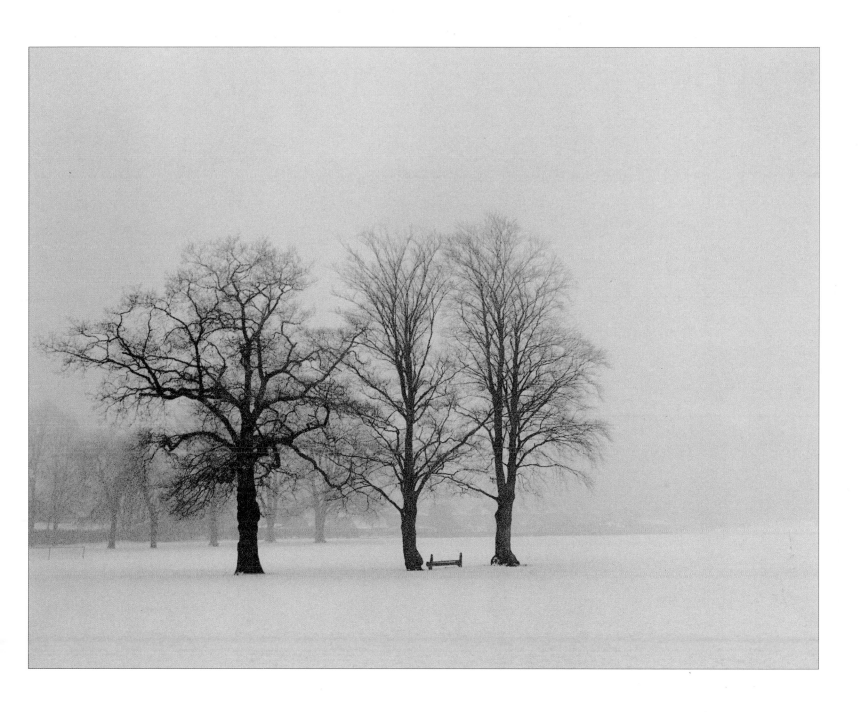

Chapter 5

Pepper Fogging, Highlight Fogging and Developer Replenishment

In this Chapter:

- *Pepper fogging on Sterling Lith paper – the affliction, the cause, the cure. Use it or lose it*
- *Allied effects on TP5 paper*
- *Chemical fogging on Kentona, Art Classic and Tapestry papers – extending the optimum effect window*
- *Developer replenishment*

THE BAD NEWS AND THE GOOD NEWS

The bad news is that the issues of either pepper fogging or chemical fogging are likely to effect the papers that you use sooner rather than later.

The other bad news is that these problems are aggravated by most of the factors which otherwise give you the most interesting lith effects – catch 22 again!

The good news however is that there are ways round all these problems and the other good news is that you can sometimes turn them to your advantage.

Closely allied to all these fogging effects is the important question of developer replenishment, so I shall look at all these issues together in this chapter and, as far as possible, approach them from a purely practical point of view – i.e. what to do if

In the next chapter I will look at some of the chemistry behind infectious development in simplified terms and how it affects the other practical issues in this chapter. Even if you are not turned on by chemistry do give it a try – or at least read the Takeaway tips. These are the points which have a practical implication in your darkroom.

PEPPER FOGGING ON STERLING LITH PAPER

• **The affliction** – In about 1995 Sterling Lith paper suddenly changed without warning in a way which markedly affected its behaviour in lith developer. It became a problem paper with a capital P and that P stood for Pepper fogging!

Fortunately, that P now stands for Problem solved or even for Pictorial tool.

This unwelcome affliction manifested itself as a rash of randomly distributed black dots on the print. These dots should not be confused with the gritty dots in emerging shadows – a hallmark of a Sterling Lith print. Pepper fogging usually started as easy-to-miss tiny black pin points most apparent in light areas. The next print would inevitably be severely affected with obvious black

dots all over. These would get progressively coarser in subsequent prints.

This problem was at its worst when the developer was just maturing nicely and if it was heavily diluted – my preferred way of printing at the time!

Although a degree of pepper fogging could be induced with some difficulty in a few other papers, it was usually minor and only with severely oxidised, old developer. The phenomenon with Sterling Lith paper was definitely something new and sometimes occurred after the first few prints if the developer was highly diluted.

At the time of writing Sterling is the only paper so affected – but emulsions are often being tweaked by manufacturers and new ones developed – so tomorrow may be another story.

• **The cause** – Pepper fogging is akin to a phenomenon known as pepperdot in lith film development and is due to accelerated and random infectious development in some grains of the paper's emulsion. This is probably as a result of the preservative, sodium sulphite, and the restrainer, potassium bromide, in the developer being diluted further than the manufacturers ever intended, as these developers were designed for film development at higher concentrations. See Chapter 6 (Lith Printing Advanced Class) for a fuller explanation.

Clearly, there is also a factor in Sterling Lith paper's current emulsion which makes it especially susceptible to pepper fogging. Exactly what it is however remains a mystery to me. I have discussed the problem with the manufacturers in India, who are adamant that the paper was never changed in any way – and yet I have some BPF (before pepper fogging) batches in my freezer which remain free of it.

• **The cure** – Now that the cause is known, the cure is obvious – simply add a little extra sodium sulphite to the working solution of the developer. Potassium bromide also helps to inhibit pepper fogging and can be added in conjunction with sodium sulphite although this must

be done with caution as bromide builds up in the developer throughout development anyway. If bromide levels become too high, the action of the developer is compromised. This is explained in more detail in Chapter 6 (Lith Printing Advanced Class). Both of these chemicals are easily available and a list of suppliers is included at the end of this book.

Fotospeed's LD 20 lith developer now comes packaged with supplies of both these chemicals and instructions on how they might be used. Speedibrew's Litho-print was developed particularly to avoid pepper fogging and its use is discussed later.

Make up a 10% weight/volume sodium sulphite solution by dissolving 100g of anhydrous sodium sulphite in about 700ml of warm water and then add cold water to make one litre. Sometimes it keeps poorly at this concentration and should be stored in an airtight bottle. If the solution appears to go off, this may be partly due to contamination of the tap water, possibly by copper or iron. The use of distilled water may help.

About 50ml of this solution added to 100ml of A + 100ml of B liquid concentrate developer should initially inhibit pepper fogging, but only for a few prints after which it will begin to appear.

Caution: Add too much sulphite and your prints will be flat with weak blacks as shown opposite. The reason for this is further discussed in Chapter 6 (Lith Printing Advanced Class). Excessive sulphite can actually dissolve silver in the print emulsion. 100ml of sulphite in the above example is usually safe and inhibits pepper fogging for longer.

The addition of a 10% weight/volume potassium bromide solution further inhibits pepper fogging and avoids the need for too high concentrations of sodium sulphite. However, potassium bromide also changes the image colour on Sterling Lith paper from a pinky-sepia towards a yellow-sepia but with excellent cold charcoal greys and blacks, and a stronger lith print effect. It significantly lengthens the development time.

Using Kodalith, Fotospeed or Novolith liquid developer concentrate, the following suggested mixture works well:

100ml Lith developer concentrate A + 100ml Lith developer concentrate B + 50-100ml 10% weight/volume sodium sulphite + 50-100ml 10% weight/volume potassium bromide + 50-100ml Old Brown + 2-3 litres of water.

NOTE: MACOlith developer is slightly different to those mentioned above in that the concentrations of A

The addition of too much sodium sulphite to the developer in order to prevent pepper fogging, can result in flat prints with weak blacks. Not only will too much sodium sulphite inhibit infectious development – see Chapter 6 (Lith Printing Advanced Class) – it can also absorb silver, thus further weakening the blacks.

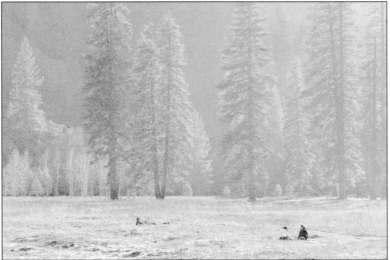

Going.... going.... gone.
Pepper fogging on Sterling Lith paper can be used as a pictorial tool, rather like a texture screen. The size and the quantity of dots can be controlled by starting with a high dilution and plenty of Old Brown – both of which predispose towards pepper fogging – and gradually increasing the concentration of sodium sulphite and possibly potassium bromide in the developer until the desired effect is achieved.

and B are different. It would require 50ml of A + 100ml of B to be substituted in the above mixture.

This should provide enough sulphite and bromide to resist breakthrough pepper fogging at this dilution and maintain a degree of consistency over a reasonable print run.

Note that higher dilutions of the developer further reduce the amount of original sulphite present. Note also, that Old Brown which has been oxidised through use, contains more bromide which has been released from the paper's emulsion than does Old Brown which has simply been oxidised by exposure to air, see Chapter 6 (Lith Printing Advanced Class).

Experiment with dilution, Old Brown and the additive percentages according to colour and effect required.

USE IT OR LOSE IT
Now that we have the cure for pepper fogging, it also means that we can carefully and fairly precisely control it if we decide we want to use it for pictorial effect. Judgement of such effects is always subjective, but I have only ever found it acceptable when fairly fine dot size is obtained – although this may be sparse or quite dense depending on the image. It can be used to give an effect rather like a texture screen as shown above.

When pepper fogging first appeared, experimentation showed me the different factors (already described) that

Even the normally very stable Kodagraph Transtar TP5 paper can be persuaded to show chaotic infectious development if abused enough. The appearance may initially be similar to mild pepper fogging but can be pushed for more atmospheric effects which can be used to pictorial advantage.

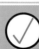

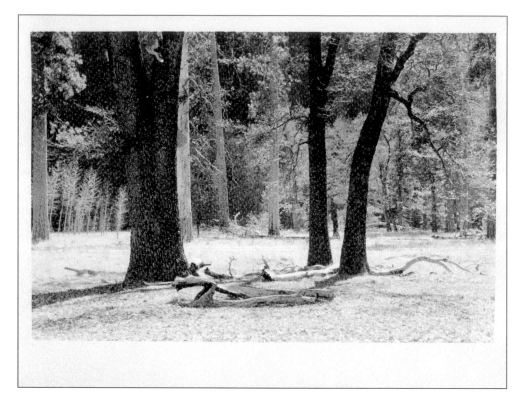

affected both size and density of the dots. Invariably these factors also affected the image colour, contrast, shadow separation and other properties that I wished to control. Changing one of these always seemed to lead to unwanted compromise elsewhere.

Now it is much simpler to control all these independently. My preferred method is to employ well used developer and gradually reduce dot size by adding sulphite, and/or bromide, with or without fresh developer or extra water, until I get the effect that I want – whilst still retaining some control over background colour and the nature of the blacks.

PRINT SIZE VS. DOT SIZE

It is important to remember that changing enlargement magnification does not alter dot size – as would happen in the case of a texture screen bound up with the negative, for example. Pepper fogging arises in the paper's emulsion and is not projected from the negative. The effect of pepper fogging will be quite different with the same dot size on a 8" x 10" print and a 20" x 16" print.

LITHO-PRINT

No discussion on pepper fogging would be complete without mention of Litho-print, as it was the sudden appearance of pepper fogging on batches of Sterling Lith paper that directly prompted the development of this new product.

Litho-print very successfully eliminates pepper fogging on Sterling Lith paper. Although image colour is very similar to that of prints made in conventional lith developer, the resulting prints do have different properties and characteristics and may benefit from a slightly modified technique. This is discussed further at the end of Chapter 8 (Toning Lith Prints).

BREAKTHROUGH BLACKS ON TRANSTAR TP5 PAPER

Kodak's Kodagraph Transtar TP5 is remarkably free of fogging as a rule and this makes it exceptionally easy to use in lith printing. It rarely pepper fogs like Sterling Lith paper, and its borders, and highlights, remain pristine white long after they would have become heavily veiled and fogged with Kentona, Art Classic or Tapestry papers.

Even Transtar TP5 has its limits though and if abused enough in heavily oxidised developer, it will produce a

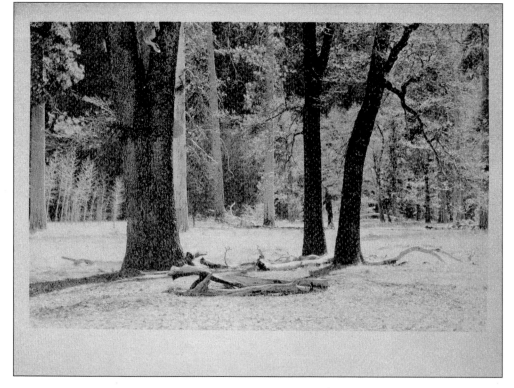

The normally narrow optimum effect window of Kentmere's Kentona, Art Classic and Fotospeed's Tapestry emulsion can be significantly expanded by the use of anti-pepper fogging additives.

Here, two parallel processing lines were set up, one with anti-pepper fogging additives and one without. Identical prints were processed alternately through each, until severe fogging occurred in the untreated line as shown. Meanwhile prints in the treated line continued to be free of fogging with good colours.

breaking through of blacks in a similar way to that seen with pepper fogging, but with a different appearance. As with pepper fogging this can occasionally be deliberately employed for effect. On page 53, I have included a print where this runaway, or chaotic, infectious development adds (in my view) to the stormy rain swept atmosphere of this picture – in a way that is in no way literal, but more to do with the creation of an impression or a feeling.

CHEMICAL FOGGING ON KENTONA, ART CLASSIC AND TAPESTRY PAPERS

In Chapter 3 (Making a Basic Lith Print) I looked at how lith developer matures with each print that passes through it to give more interesting results. In that illustration I used Kentona paper. Art Classic and Tapestry behave in the same way, the colours becoming stronger until the maximum effect is reached, whereafter the next print will show fogging of the margins, and the highlights, which increases with each subsequent print.

Early border fogging may be easily missed in the wet print but becomes much more apparent on dry down. Special attention should therefore always be given to the borders with these papers and it is useful to have a small piece of processed, unexposed, unfogged paper to match against them.

HOW TO EXPAND THE OPTIMUM-EFFECT-WINDOW

With these papers this optimum-effect-window is very small – just one or two prints. It is important not only because it gives the best colours whilst retaining clean whites, but also to achieve the maximum multicolour effects which these papers can give in selenium toner, as we shall see later. in Chapter 8 (Toning Lith Prints).

I have found in practice that there is an easy way to expand this window to produce more peak-effect prints per run and very conveniently, although not surprisingly, it is exactly the same cure as for pepper fogging – great when you are using both types of paper in the same session.

The two prints opposite demonstrate chemical fog inhibition on Tapestry paper, using the pepper fogging additives described earlier. Parallel processing lines were set up with and without these developer additives. The prints were processed equally in each developer until severe fogging occurred in the untreated developer, whilst the treated developer prints remained unfogged. The same results were obtained with Kentona and Art Classic papers.

REPLENISHMENT

The high dilution of developer often used in lith printing means that the solution in the developing tray may actually contain only very little active developer with a correspondingly small working capacity. I tend to use the higher dilutions and therefore make up large volumes to obtain some degree of consistency. As we have seen, the colours improve as the developer is used and are at their best either just before the developer fails or (particularly with Kentmere papers developed in Kodalith) before chemical fogging occurs. Although fogging can be postponed, developer failure is ultimately inevitable if you keep printing.

Rather than throwing the developer away at this point and starting again with fresh developer, it is possible to replenish the mature developer with fresh concentrate and keep that window of optimum effect open even longer.

Before going to safelight, I always measure out a further 100 ml of A and 100 ml of B together with 50ml of sodium sulphite, into an otherwise empty two litre jug. When the time comes, I pour developer from the tray into this jug and then pour the replenished mixture all back into the tray. This gives better mixing than just adding the concentrate straight into the tray. It also avoids having to measure out concentrate under safelight. (However, it does take practice to pour from such a full 20" x 16" tray.)

For subsequent replenishment, as the amount of oxidised developer increases, I find it better to dilute the replenishment concentrate to a litre and pour away a litre of old from the tray before adding it. This gives better results and also stops the volume from becoming too large. Continued replenishment beyond this is likely to be associated with a deterioration of print quality, see Chapter 6 (Lith Printing Advanced Class) for a fuller explanation. At this stage I would use this developer as an Old Brown additive to a fresh brew.

The choice of developer has a significant effect on the need for replenishment. Kodalith liquid peaks to optimum lith effect fairly quickly – but it also dies and needs replenishing more quickly and this is particularly apparent when using Kentona. Champion Novolith and Fotospeed LD 20 were designed with tank and replenishment systems more in mind, the result being that they peak more gradually but keep going longer without replenishment with more even consistency in the results. In terms of aesthetics, each paper and developer combination has its own devotees.

In the case of breakthrough pepper fogging on Sterling Lith paper it may only be necessary to replenish with sodium sulphite and/or potassium bromide. Scrutinise the highlights of each print for the first signs of tiny dots – the next print will be badly affected if additive replenishment is not undertaken.

Caution

It may be tempting to disregard early chemical fogging on the pink papers – Kentona, Art Classic and Tapestry – in the belief that they can be cleaned up later with a bath of Farmer's solution. Don't! The pinks will be lost and the image will turn brown.

Tip

It pays to add sodium sulphite/ potassium bromide to your working strength developer, no matter which type of paper you are using.

It is particularly useful with Sterling Lith, Kentona, Art Classic and Tapestry (UK names) but can also delay chemical fogging in some other papers.
NOTE: US/Australian readers are referred to the Equivalent Names table at the back of this book.

Lith Printing Advanced Class

In this Chapter:

- *The chemistry made simple*
- *Infectious development*
- *Pepper fogging*
- *Replenishment*
- *What's going on?*
- *What's going wrong?*
- *Why it matters and what to do about it*

> Turned off by chemistry? Try this simplified version of chemical events. In any case read the boxed Takeaway Tips which have practical applications in your darkroom.

Takeaway Tip 1

Remember, paper emulsion releases bromide into the developer. Bromide levels in the developer therefore increase during a printing session. Sulphite levels fall.

Fortunately, for most of us a knowledge of chemistry is not required in order to make good prints. The pioneers of photography have taken care of all that for us. All we have to do is follow the instructions on the packet – right?

Well, up to a point this is true. However, what happens when the lith developer in your dish has been repeatedly tinkered with? Over-diluted, old stock added, extra bromide and/or sulphite (the and/or does matter) stirred in and replenishment undertaken – and do we add more sulphite or bromide at this point? Sooner or later you end up with a soup – and it may even look like soup by now – that bears little resemblance to the original contents of the packet.

With continued use things quickly go off track and print quality takes a dive with weak blacks, veiled highlights, stains and flat prints that don't readily respond to reducing exposure, and maybe do not even respond now to adding more developer. What next?

That is what this chapter is for.

The chemistry of lith developers is of course well documented. But what is happening at molecular level on the emulsion surface? Why does infectious development accelerate exponentially in the dark tones? Why does pepper fogging happen?

The answers are not easy to find and little has been written up about it in the public domain. Much of the following has been compiled from unpublished research data.

Serious students of photo-chemistry please note that this chapter is written for non–chemists!

The first thing to appreciate is that this process is a complex dynamic, in which we have to consider not only the effect that the developer has on the paper's emulsion, but also the effect that the emulsion has on the developer – and that, of course, effects how the developer acts on the emulsion. It is a constantly changing dynamic and we should remember this when we consider adding anything to the developer.

GENERAL POINTS

Lith developer is very sensitive to;

- changes in pH
- hydroquinone concentration
- sulphite levels
- bromide levels.

1). The **pH** scale ranges from 1 to 14 and indicates the level of acidity (below seven) or alkalinity (above seven). The higher the pH, the more active the developer – and the faster it oxidises. Lith developer is very strongly alkaline with a pH usually around 13.

2). Hydroquinone is a developing agent. It affects throughput or capacity and with high pH has high activity, and high contrast characteristics.

3). Bromide is a restrainer and inhibits hydroquinone activity as we shall see shortly, thus affecting development speed. It is also released into the developer from silver bromide in the emulsion during development. Bromide levels increase with throughput. Bromide inhibits fog.

4). Sulphite is a preservative added to developers to inhibit their oxidation either by exposure to air or during development – or both. In lith developers, high sulphite levels lower contrast and may even absorb silver, whilst low levels cause a high rate of oxidation of hydroquinone. This may lead to pepperdot on film and pepper fogging on lith paper.

INFECTIOUS DEVELOPMENT

This is a typical chain reaction and consists of three stages;

1). Initiation Stage – Ionised hydroquinone ('HQ') reacts with the silver halide* (mostly bromide) in the paper's emulsion at a latent image centre ('L.I.C.')* that has been formed by the action of light upon the emulsion. This forms silver, halide (mostly bromide) and a highly reactive semi-quinone radical ('SQ').

 a). Silver Halide + 'HQ' ——> Silver + Halide + 'SQ'.
 * See the Jargon Buster box at the end of this Chapter.

2). Propagation Stage – This highly reactive semi-quinone reacts with silver halide. It is so reactive that it

tends to react with any silver halide – whether it contains an L.I.C. or not. This reaction forms visible silver, a halide (mostly bromide) and quinone ('Q').

b). Silver Halide + 'SQ' ——> Silver + Halide + 'Q'.

What happens next is the chain reaction at the heart of infectious development. This quinone reacts with ionised hydroquinone, to give two further highly reactive semi-quinone radicals.

c). 'Q' + 'HQ' ——> 2 'SQ'.

3). Termination Stage – Here, quinone reacts with sulphite to form hydroquinone monosulphonate – an end-point reaction that leads nowhere. Activity therefore ceases.

• Implications
It should be clear from this that quinone ('Q') produced in the second stage has two options. It can go down the *propagation pathway* – or the *termination trail*.

If sufficient sulphite is available this quinone is more likely to react with sulphite ——> termination (see overleaf).

As sulphite is used up, its levels fall locally and the propagation pathway is pursued. This leads to the following explosive chain reaction of infectious development;

i). 1 molecule 'Q' + 1 'HQ' ——> 2 'SQ' (see c). above)

ii). These 2 'SQ' > 2 Silver + 2 molecules 'Q' (as in b). above)

iii). These in turn give 4 'SQ' radicals, then 8, 16, 32 – and so on in an exponential progression. This results in a parallel exponential rise in visible metallic silver. You witness this happening in your dish as the dark tones approach snatch-point.

• Sulphite Balance
The balance in this system is a delicate one. Too much sulphite and no chain reaction occurs. Too little sulphite and chaotic random infectious development is likely – pepperdot on lith film and pepper fogging on Sterling Premium F Lith paper. As luck would have it, two of the main factors that improve the lith effect in lith printing are high dilutions and maturing (i.e. partly used) developer – both of which lower sulphite levels considerably.

Restoration of sulphite levels, as described in the previous chapter, swiftly eliminates pepper fogging, but

if too much is added, the termination stage prevents the development of good blacks and prints are too weak and flat.

• The Role of Bromide
The bromide in the developer also plays a critical role.

It is thought that the negatively charged bromide ions (Br–) are adsorbed onto the silver halide lattice, where they present a layer or barrier of negative charge, that inhibits development.

This barrier must be shifted by the doubly charged hydroquinone that replaces the Br– before it can itself reach the silver halide lattice and onto which it becomes adsorbed.

This takes time – a period known as the induction period (I call it the music interval in lith printing!), during which bromide is released into the developer.

When this hydroquinone has become adsorbed onto the silver halide, it can pass an electron to the silver halide crystal and convert a silver ion, Ag+, to metallic silver Ag

i.e. Ag+ + e– ————> Ag (visible silver).

Without replenishment of the developer, the situation arises that as more paper is developed, more bromide is released and the harder it becomes for hydroquinone to overcome this bromide barrier. This of course is accompanied by a falling level of hydroquinone, through use as well as a fall in pH.

• Replenishment Considerations
All this has implications, if using developer replenishment to keep that optimum-effect-window open longer, as described in Chapter 5 (Pepper Fogging, Highlight Fogging and Developer Replenishment). The more the developer is replenished, by simply adding more fresh concentrate into what is now a bromide-rich environment, the further the bromide levels will rise and hydroquinone activity will be even further inhibited. This would clearly be compounded if bromide additive had initially been used to inhibit pepper fogging and, doubly so, if more bromide were to be added with the replenisher.

Bromide levels will be higher in Old Brown solutions that have been oxidised by use, rather than simply by exposure to air – especially if bromide additive had been initially included to prevent pepper fogging.

Sulphite, hydroquinone and pH all tend to fall in heavily replenished systems too, so all the main factors in successful lith development are getting progressively

Simplified Infectious Development Flow Chart

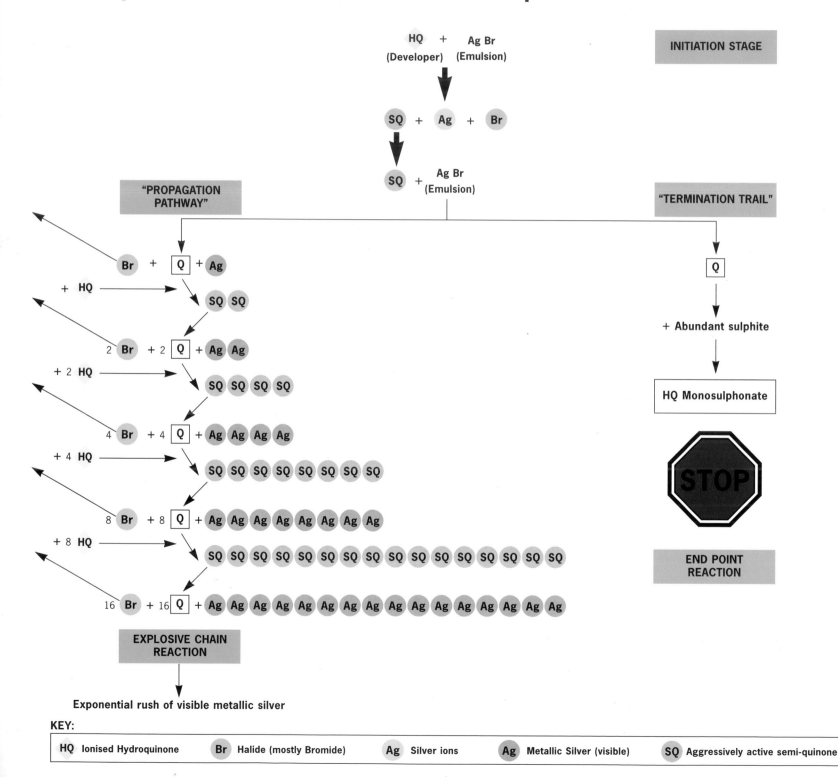

KEY:

HQ Ionised Hydroquinone **Br** Halide (mostly Bromide) **Ag** Silver ions **Ag** Metallic Silver (visible) **SQ** Aggressively active semi-quinone

The effect of processing steps on lith developer

Action	Hydroquinone	Sulphite	Bromide	pH
On dilution.	↓ Small throughput.	↓ Improves infectious development chain reaction – may approach pepper fogging levels.	↓ Less restraint on hydroquinone.	* ↓ Lower oxidation rate. Less high contrast effect. Slower development.
Add anti-pepper fogging additives.		↑ Slows oxidation. Stops pepper fog. If too much, low contrast and weak blacks.	↑ Slows development. Colour shift plus cold blacks on Sterling Lith paper.	(v. slight) ↑ Negligable effect.
Continued use.	↓ Reduced capacity Ultimately "standstill".	↓ Pepper fogging on Sterling Lith paper. Improved colours.	↑↑ Inhibits hydroquinone. Slows development.	↓ Slower action. Lower contrast from hydroquinone.
Replenish with neat lith developer.	↑ Increased capacity.	↑ Stops pepper fog.	↑ Inhibits hydroquinone.	↑ Increased developer activity. Improved contrast.
Replenish with dilute devloper. Discard equal vol. of used dev.	↑ Increased capacity.	↑ Less fogging. Good blacks. Clean highlights.	↓↓ More developer activity. Less fogging.	↑ More developer activity. Improved contrast.

*** pH falls significantly on dilution of hydroxide-rich developers. Carbonate-based developers retain alkalinity better on dilution.**

more off track. Commercial replenisher solutions used in processing machines have a lower bromide concentration along with higher sulphite, hydroquinone and pH to counter balance these effects. Often dual replenisher solutions were used to compensate for the differences in aerial and use oxidation.

In the amateur darkroom dish system, this is neither practical nor necessary, but continued simple addition of concentrate soon leads to declining performance. This is why I recommend removing progressively more old solution with each replenishment after the first.

If sulphite and bromide have initially been added to the developer to suppress pepper fogging, subsequent break-through pepper fogging may be best dealt with by sulphite addition alone for the reasons stated. Champion and Fotospeed lith developers both appear to require less replenishment than Kodalith. A side chain substitution was introduced by Champion to make their developer require less replenishment and LD 20 seems to behave in a similar way.

The reader is referred to the Lith Printing Troubleshooting Guide on page 110.

The reader is referred to the Lith Printing Troubleshooting Guide on page 110.

Jargon Buster

- Ag+ – The chemical symbol for Silver.
- Halides – A chemical group consisting of bromide, chloride, iodide and fluoride. The former three are used in photographic emulsions combined with silver - silver halides. The latter is commonly found in toothpaste.
- Lattice – Silver bromide crystallises in a cubic pattern. The arrangement of the atoms on the upper surfaces of the cube is known as the lattice.
- Latent image – Invisible until developed, an image formed by the action of light on silver bromide crystals in gelatin emulsion.
- Development – Reducing 'grains' of silver bromide to give visible metallic silver in the emulsion.
- Emulsion fog – Visible tone caused by the presence of silver bromide which develops without the action of light. Commonly seen in Kentona, Art Classic and Tapestry papers used with bromide-rich developer.

Takeaway Tip 4

- If you have added much Old Brown when making up your developer – and particularly if it was very brown from heavy use, as opposed to air exposure, you may consider using sulphite alone to inhibit pepper fogging.

If you use light Old Brown plus a very high dilution, both sulphite and bromide can be used for the first mix.

Colour Control – without toners

WHY THE END IS REALLY THE BEGINNING

Learning to make a lith print is easy. Learning to control what can sometimes seem a wayward process takes a little more practice – but you now have all the information you need in order to do this. The trick is to make the process subservient to you rather than the other way round.

Having taken control, you will soon start to think about where to take the process next. As with any finished print, a lith print is never finished until you have finished it! There are always further steps you can take to modify the image you have produced. Sometimes these will be fine tuning, other times they may be quite radical. It may be that your final objective was to produce a lith print and now you want to tinker subtly with the final colour. Alternatively, it may be that the lith print process was simply chosen as a stepping stone to a pre-visualised image that could not be reached any other way – for as we know lith prints have properties that other prints do not have.

COLOUR CONTROL

Lith prints of course already have a distinctive warm tone colour that is emulsion specific – a pinky or yellowish sepia in the case of Sterling Lith paper, rich browns, peach colours or sandy-beige with the Forte family, delicate pinks and reds with Transtar TP5, Kentona, Art Classic and Tapestry (although all these latter papers are caramel coloured when wet) and pinky-beige or rich brown with the MACO Expo series.

Control of image colour can be important for a number of reasons;
- **Aesthetic factors.** Different colours convey different messages, and some would say, emotions. Even subtle tonal variations in colour temperature effect the way an image communicates.
- **Conflicting objectives.** In lith printing many of the properties of the print are related directly to the grain size in the paper's emulsion. This can make certain qualities mutually exclusive. It is possible to change this relationship by colour control, allowing you, for example, to have a warm-tone high contrast print instead of a cold-tone one – or a cold-tone low contrast print instead of a warm one.

- **Toner response.** Especially with some paper/toner combinations the colours available in the toning bath are dictated by the colours achieved in the original processing.

It is therefore useful to be able to control or change image colour both during as well as after processing.

Image colour control techniques can be classified as follows;
- During processing
- Post processing – bleaches
- Post processing – toning
- Bleach and re-development

These will be examined in this and the following two chapters.

COLOUR CONTROL DURING PROCESSING

1). Developer related;

a). *Developer dilution* – Although this may vary with different paper development combinations as well as with other processing variables, higher dilutions are more commonly associated with warmer highlight and mid-tones – stronger developers with colder tones.
b). *Developer maturity* – As we have already seen, fresh developer produces less interesting results – including suppressed colours – this is true of all papers in lith printing, but especially the warmer tone 'pink' papers.
c). *Developer additives* – Potassium bromide will cause Sterling Lith paper to shift from a pinky-sepia to a yellowy-sepia with colder charcoal blacks. Benzotriazole could be expected to cool image tones, but I have not used it in this context.
d). *Developer temperature* – High temperature techniques can be useful both in first development and in re-development after bleaching to maximise colours.

As stated earlier, lith printing with Multigrade Warmtone will give more interesting results at 40°C.

The Rock Face prints opposite were made on Ilford's Multigrade Warmtone (top) and Kentmere's Kentona

Developer temperature. Different papers have their own individual characteristics in lith printing. This is reflected in their response to changes in processing technique – in this case the use of high temperatures in development.

At around 40°C Ilford's Multigrade Warmtone produces typical ivory tones with convincing infectious development in the blacks, whilst Kentmere's Kentona gives rich oranges or maroons, depending on the progression of development that is allowed.

A.

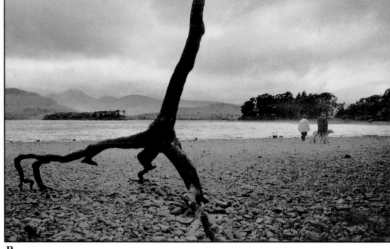

B.

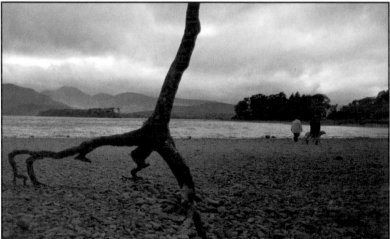

C.

Turbo fix-up. These three prints of The Stalking Tree illustrate the effect of the turbo fix-up technique on Kentmere Kentona paper. The same results will be achieved with Kentmere Art Classic and Fotospeed Tapestry. The same effect but with different colours can be achieved on some other papers.

A. *Shows the typical colour of Kentona in fresh Novolith or LD 20.*

B. *Shows the maximum pink at normal temperatures when the developer is mature.*

C. *Shows the extra colour from the turbo fix-up technique – in this case three stops more exposure was given than in A. and B. Despite this amount of exposure the whites in the sky are well preserved and not fogged. Contrast in the mid-low tones is only slightly reduced here and varies with the snatch-point (see text).*

Tip

If you cannot get a decent black after Turbo fix-up, it may be that you are developing just too much – or just too little. The technique is quite different to the normal lith technique and you have to really get a feel for it.

(below) at 37°C. The colour achieved with Kentona can be changed from a delicate or bright pink to an orange or maroon at higher temperatures. Although these deep, rich colours may be satisfying in their own right, they also effect the response to toners. This is particularly true of selenium and gold toners, both of which can produce an extended range of intermediate hues with these colourful prints before the end point colour is reached.

As high dilutions extend development times and high temperatures lower them, there is clearly a place for combining both techniques.

e). *Development evolution* – As we have seen, colour alters through early development (remember the GOLDEN RULES). Transtar TP5 for example can conveniently be processed to a light pink, salmon or through to brown by adjusting exposure and snatch-point – together with a). and b). above.

2). Exposure and Development related

a). *Contrast and colour* – Colour is linked to contrast according to the exposure/development ratio as we have seen. This link can be camouflaged by post-processing treatments with bleaches and/or toners.
b). *Over exposure and Turbo fix-up technique* – The accompanying Stalking Tree series shows how the colour range – of Kentona in this instance – can be extended by this technique to produce vivid ochre and orange colours. Sterling Lith paper can yield warmer pink colours.

The paper is massively over exposed – by about another three stops according to the effect required. For the

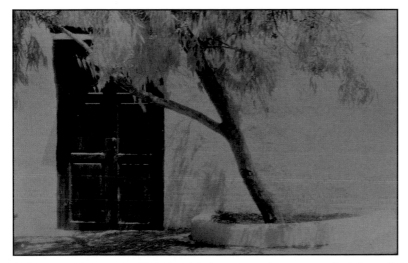
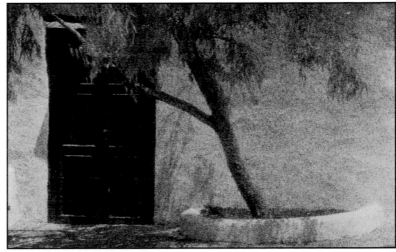

Flashing in late development, or timed flashes through development, can produce interesting results which vary with the type of paper. Transtar TP5 (above left) can give intense colours with or without solarisation effects in the shadows. Bromide tanning is common (see text). The image top right shows the pencil-sketch effect on the now discontinued Kodak Rapid paper. All new emulsions are worth experimenting with, although results may be unpredictable.

mathematically challenged this equates to five stops above the exposure required for the print in normal developer. As every one stop increase doubles the exposure, a test exposure of 20 seconds increased by five stops has now become 640 seconds! The reason that this doesn't give you a print of about contrast grade minus two, is that the print density is so great that it can be snatched when the grains are at an even earlier stage of development, when they have what has been described as a filamental grain structure.

Likened in appearance to tangled seaweed or perhaps a snowflake, these delicate strands or filaments are especially vulnerable to being bleached away by the fixer – leaving an extra tiny and more colourful grain core.

As always with lith printing, results vary greatly with different papers but also vary with the type and state of the developer in use. Bright colours are generally easy to achieve with Kentona, Art Classic and Tapestry. The print should be allowed to develop until it looks just too dark. It will also look very, very flat indeed. The timing of the snatch-point is especially critical here.

It should be slid swiftly into a cold stop bath and on into the fix, whereupon the mid-tones will lighten dramatically and the previously very poor low values will suddenly consolidate into rich blacks with a consequent jump in contrast. If you were to put on the light as you slide the print into the stop bath, you would see that the image appeared to be covered by a milky magenta or bluish veil according to the paper. In the fix this fine veil appears to lift and the print snaps-up – a real Turbo fix-up effect!

c) Flashing during development

I experimented with this technique some years ago and although I rarely use it, it deserves a mention here.

Earlier in this book I mentioned that because the light tones in a lith print are progressing so slowly in the developer, it is possible to flick the room light on briefly whilst the print is approaching the snatch-point in the developer. Providing that this is timed correctly, and the light exposure is not too long, a quick preview of the print is possible in white light and yet the print may still be transferred safely to the stop, and fixer, baths before any visible fogging occurs.

Whilst this manoeuvre has obvious advantages, it is not entirely without its drawbacks. If the print turns out to be less advanced than was thought - a common mistake with novice lith printers – it either has to be fixed before it is ready or it has to be developed longer than anticipated, with the obvious risk of fogging. Needless to say, this risk is especially high with Kentona, Art Classic and Tapestry papers, as their common emulsion is prone to easy fogging during processing in any case. It also has the disadvantage that it compromises your low light vision for a while after the light has been turned off, making it difficult to assess the progress of the print for a short period.

Having discovered this quite considerable safe un-safelight window – several seconds if timed correctly - I experimented to see how far before snatch-point the light could be switched on, and what happened if exposures were made before that point. I found a variety of effects could be achieved, both on colour and other image characteristics. These are dependent on

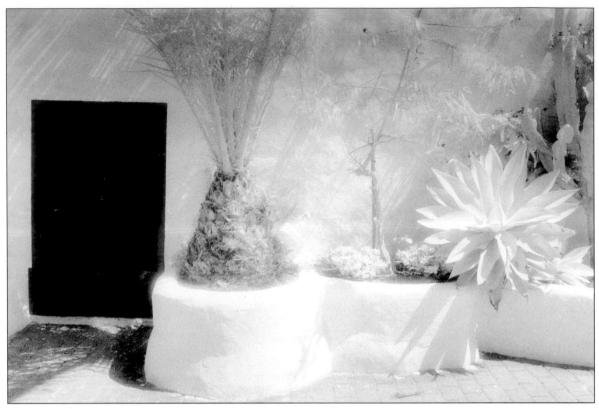

paper type and the state of the developer, as you would expect.

Pepper fogging may be accelerated on Sterling Lith paper in untreated mature developer, whereas TP5 in fresh developer acquires a significantly enhanced colour. Flashing progressively earlier produces deeper colours on TP5, which can be striking in appropriate images, particularly if the fogged borders are subsequently covered by a mat overlay. The flashing exposure can be divided into two or three separated exposures through development. Progressive exposures cause high bromide levels to be released into the gelatin to cause tanning, that may be accompanied by subtle tone separation effects. If silver is subsequently removed by bleaching, a positive tan image may be left in its place. There is clearly scope for further bleach and re-development games along these lines.

The now discontinued Kodak Rapid paper reacted in quite a different way and I mention it here because with new emulsions continually being researched, and marketed, it is not unlikely that other papers will, or may even now, react in the same way. When flashed between half and two thirds of the way through development, this paper produced a grainy pencil sketch appearance, which was both reproducible and controllable. This was

presumably a more delicate forerunner to the pepper fogging which was to later appear on Sterling Lith paper.

COLOUR CONTROL WITH BLEACHES

Before we go on to look at the sometimes very colourful effects of toning lith prints, it is perhaps worth briefly considering the rather more subtle effects that can be achieved on some papers by the use of very weak bleaches.

The bleaches I use for this are;

1). Weak potassium ferricyanide – say 10mls of 10% stock solution into one litre of water as a starting point.
2). Weak bleach from a variable sepia toner kit such as Fotospeed. These are based on a combination of potassium ferricyanide and potassium bromide. Wide variations in working strength solution are possible, starting at say 10% of the normal recommended concentration.

The effects of these two ferricyanide bleaches on lith prints are surprisingly different.

A weak ferricyanide bath will cool off both Sterling Lith paper and the Kentona, Art Classic, Tapestry type

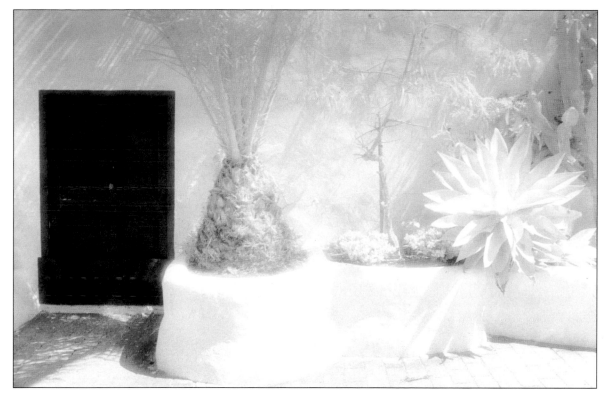

Tips

1). With weak bleaches the colour shift is gradual and the eye easily acclimatises to small changes without registering them.

2). Always keep a wet similar print alongside for reference. Pull the working print regularly from the yellow bleach and rinse to assess the colour.

3). This very gentle bleaching can be achieved with minimal loss of highlight detail, provided that meticulous care is taken to remove all traces of fixer beforehand.

See Ilford's recommended archival programme on page 124 Also, the Hypo-clear alternative at the end of Chapter 9 (Bleach and Re-development Games).

4). The bleaches provided in commercial sepia toning kits are not all identical and results may vary with lith prints treated in different makes of bleach.

papers to shades of colder brown. Similar results are obtained with some Forte and MACO papers (see tables at the back of the book).

Much more interesting results come from bathing Sterling Lith paper in the weak ferricyanide/bromide bleach. You will recall that addition of bromide to the developer to combat pepper fogging, caused the Sterling lith image to shift from a pinky-sepia to a more yellow sandy colour. The ferricyanide/bromide bleach will shift it initially to pink and then on to violet or lavender hues.

These colour changes depend absolutely on your processing in the developer. Sometimes they are quite obvious, but sometimes they can be extremely subtle, so it is wise to have a wet reference print alongside. A useful colour control for Sterling Lith paper, this process must be carried out carefully and cautiously to avoid unwanted loss of tones. If this is planned in advance, it may pay to give light delicate prints an extra quarter of a stop exposure to protect the lightest tones.

This colour change does not happen to a significant degree with either the Forte or MACO ranges of paper, where bleaching can be more useful for cleaning up the prints, brightening the highlights and removing unwanted fog.

Bleaches cause marked colour changes on lith prints made with many papers. Whilst this can be an unwelcome surprise if attempting local bleaching, it is a double-edged sword and can be very valuable in controlling the eventual colour of the image.

The two prints shown here are lith prints on Sterling Premium F Lith Paper. The one on the opposite page displays the cooler tones often seen when potassium bromide has been added to the developer in order to control pepper fogging. The print on the right shows a print originally of identical colour that has been bathed in very dilute potassium ferricyanide/potassium bromide bleach (as found in sepia toning kits) Despite fairly prolonged bleaching, only the slightest loss of highlight detail has occurred. This technique can produce hues of pinks, lilacs and greys. Other papers react in different ways, details of which can be found in the tables at the back of the book.

Chapter 8
Toning Lith Prints

In this chapter we move on from the colour controlling techniques of the previous chapter to colour changing with toners.

If you are new to lith printing, you will be astonished at the range of responses to selenium and gold toners, which is far beyond that achieved with conventional prints.

As always, the results are a matter for your own interpretation and may include;
- Returning the print to conventional black and white shades – perhaps where the lith printing technique was used only for its other properties like printing hard in the shadows and soft in the highlights
- Subtle warming up, cooling down or split two–tone effects
- Rendering the image in an overall completely different colour
- Multicolour effects. These can be striking or subtle and gentle.

TONERS

Although any toners may be used with lith prints, the ones I use most are selenium and gold. Occasionally I use sepia, but rarely copper and never blue. Many of the copper toning colours can be achieved by other means. Blue toner, that is anyway archivally unstable, cannot begin to match either the range or the wonderful depth and clarity of the blues produced by gold toner on lith prints. Selenium, gold and sepia toners all increase the archival permanence of the prints and can be used individually or sequentially – but the order is important.

The results with selenium are emulsion specific and vary with the paper used, as well as with both the processing and the toning techniques.

SELENIUM TONER

Selenium toners are available from Kodak and Fotospeed through Silverprint and other distributors, a list of which is given at the end of the book.

• Selenium Safety

Selenium is potentially toxic and should be used in good ventilation. I recommend that rubber or vinyl

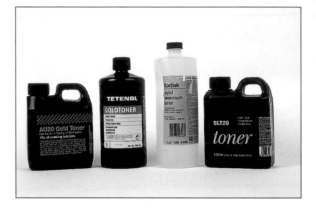

gloves should be worn. Opinions are divided about the safety or toxicity of selenium. It is an important trace element in our diet in minute quantities. Selenium toners are usually based on concentrations of about 2% sodium selenite and this is diluted for use. Some maintain that it is a potentially dangerous and possibly cumulative poison absorbed through the skin, eyes, and probably by inhalation of fumes. Others dispute this. In the presence of any uncertainty it makes sense to err on the side of caution without becoming alarmist. We are still discovering toxic effects from previously 'safe' substances in common use. Pyridoxine (B6) is a salutary recent example. Whilst our knowledge remains incomplete, I shall wear gloves when using selenium!

The toner comes as a liquid concentrate and should be diluted for use according to the effect required. I find a dilution of about 1 + 6 to 1 + 9 is ideal for toning most lith prints, although I do also use it at dilutions from 1 + 2 (**Care** – see below) to 1 + 20.

It stores well even when diluted. I keep stock solutions at 1 + 20, 1 + 9 and 1 + 5 and replace only when toning gets noticeably slower. A flaky sludge will form in the bottles – you can safely ignore it – the toner will continue to work despite this.

The wet print should be immersed in the toner and removed to be washed (preferably under running water) when, or slightly before, the desired effect has been reached. The process is carried out in daylight or

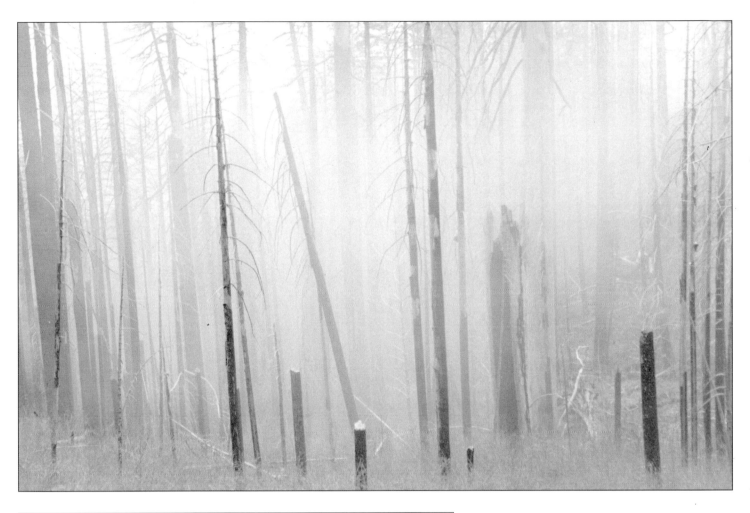

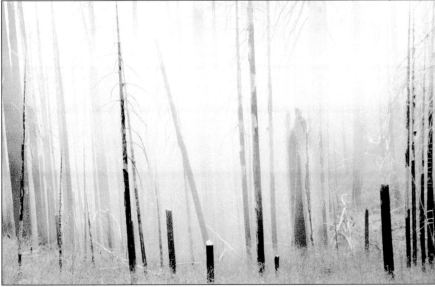

Sterling Premium F Lith paper can produce beautiful split-tone effects when lith printed and toned in hot, strong selenium(see text). This is quite different to the effect seen with this paper in dilute selenium. The results resemble a reversed split-sepia toned effect but with no loss of highlight detail. **Warning:** *Great care should be taken with hot selenium at this concentration and good ventilation is essential.*

Caution – Hot 'n' Strong Selenium Technique

Hot selenium at this concentration is highly unpleasant to work with. Good ventilation (like a field!) is essential. Never use in a closed confined space.

artificial light, preferably daylight corrected (e.g. North light bulbs). Selenium always affects the darkest tones first and it is here that you should direct your attention during toning.

COLOUR CHANGES IN SELENIUM

• *Sterling Lith prints in Selenium Toner.* This paper is much more versatile in selenium than is generally appreciated and images on it can be transformed by this toner.

For my own practice I have developed two different approaches to selenium toning my Sterling Lith prints.

1). Normal working strength – At normal temperatures with a dilution of, say, 1 + 9 to 1 + 15, Sterling Lith prints of warm-tone and low to medium contrast will initially show a shift towards pink, before changing to a brown close to the original colour. Eventually these prints take on the typical plummy-brown hues of selenium, predominantly in the shadows. Once again, a wet reference print is useful particularly for the early subtle colour shifts and, of course, the print can be pulled at any desired stage.

2). Hot 'n' Strong – I have found that the response described above can be significantly changed by greatly increasing the concentration and temperature of the selenium.

My preferred technique here is selenium toner at 1 + 2 at 40° C. When I say preferred however, I am talking strictly in terms of results – not the actual procedure – see the Caution box before you consider trying this. The vapours are quite suffocating and irritate the eyes if used indoors – especially with larger volumes in 20" x 16" trays. 10" x 8" dishes present only a quarter of the surface area of solutions and are less unpleasant to work with.

I maintain the temperature with a dishwarmer and soak the prints in hot water before toning, as a few cold prints of large surface area will swiftly lower the temperature in the toning bath.

The image changes follow a cycle and the print can be pulled at any time and hosed with cold water to stop the reaction. I suggest you take at least one print the distance so that you know what the options are.

The cycle starts with a brown untoned print, then goes through grey and back to the browns. First, there is a sudden intensification of blacks that snap-up to a striking cold charcoal-black from the warm blacks of the original print. A plummy coloured warming-up of the image then occurs, following which the image goes cold in colour, working from the shadows up to the highlights, so that you now have a cold-toned black and white print with an enhanced D-max.

Here the point is reached where patience pays off, as the lower tones slowly begin to turn to a brown that gets steadily richer and warmer. Sometimes it is easier to spot this beginning in a dark grey rather than a black.

As in the picture of the Misty Forest, on the previous page, the print can be pulled at this point to show lovely delicate cold grey highlights against rich warm tones. How far the brown is allowed to climb up the tonal scale to balance the cold greys is entirely a matter of judgement and is in your control.

The result is rather like a reversed split-sepia tone but with absolutely no loss of highlight density.

The colour of the darker tones is dictated by both the initial processing and the time in the toner.

• *Multigrade Warmtone Lith prints in Selenium Toner.* Although lith printing Multigrade Warmtone expands the range of image tones and effects that this lovely paper is capable of, I do not personally find the untreated lith effect as interesting as some of the other papers discussed. However, it does respond to my hot and strong selenium treatment to give attractive plummy-red tones. Patience is required.

I will look at some very different colour effects on Multigrade Warmtone lith re-development in the next chapter.

• *Kentona, Art Classic and Tapestry lith prints in Selenium Toner.* These papers deserve special mention with regard to their response to selenium.

Prints processed either for high contrast or cooler tones will initially cool off to a bluey-grey, following which a deep, cold brown develops in the shadow tones. This gives a striking grey/brown split – and the print can be snatched at this point or left until the browns eventually work their way up through all the tones in the print.

However, prints developed to a bright pink or red and a medium contrast can yield spectacularly colourful prints. The colours change from pink to mauve to lilac to grey and finally to a rich mid-brown. As always with selenium, the colour change starts in the shadows. As the first colour moves into the mid-tones, the shadows are changing colour again. In prints with a long tonal range, the colours can be seen chasing each other up through the tones from shadows to highlights and the print can be pulled at any time to freeze the colours reached. The example of the gondolas (shown opposite) has been snatched from the toner about half way through, to show the range of colours – all from a single toner.

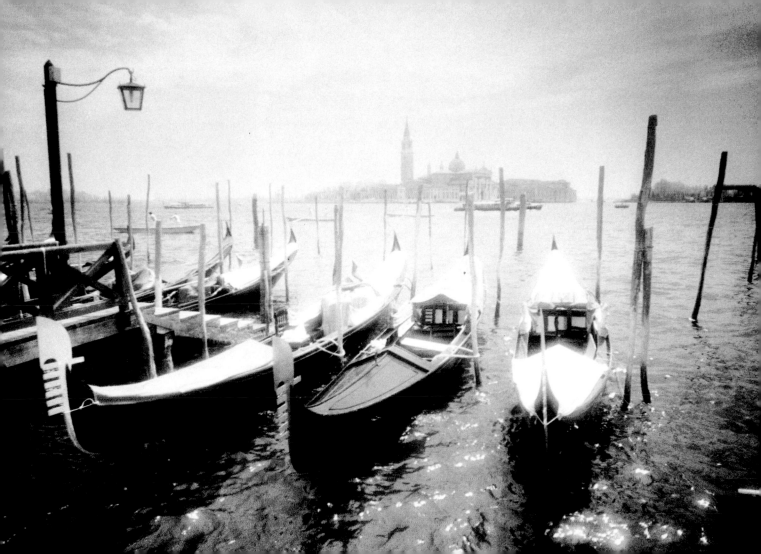

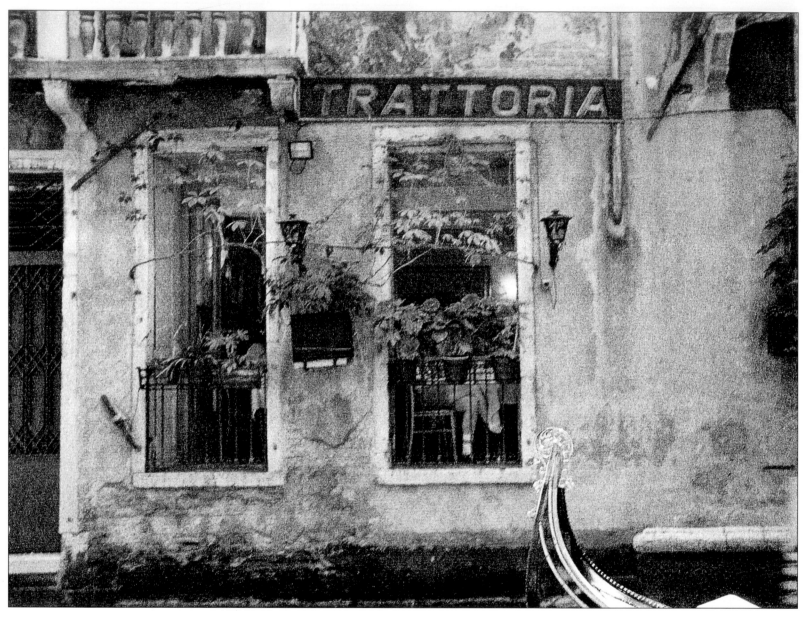

Fotospeed's Luminos Tapestry paper lith prints to produce warm pinks on a heavily-textured, heavy art paper. In dilute selenium this yields a range of muted pinks, blues and browns. Together with the textured surface of the paper this makes an ideal medium for hand-colouring, that blends comfortably with the background colours.

A softer print pulled earlier from the developer and having smaller grain size throughout will give bright ginger in the shadow and cold greys. This is very striking but can look sickly in some prints. Only practice and experience can allow you to get the balance right for each picture. The final image really needs to be pre-visualized already at the stage of exposing the paper under the enlarger.

Although these papers respond in a very similar fashion, it is my impression that brighter and more distinct colours are achievable on Kentona and more

muted and pastel shades with Art Classic and Tapestry. Some of this effect may be related to the ivory tint or to surface differences as the emulsion is the same.

The picture of the gondolas illustrates something of the bright colours that are possible with a Kentona lith print in selenium toner.

This print, shown on the previous page, has been pulled from the selenium toner about half way through the toning cycle in order to capture the full range of available colours. At least half a dozen significantly

different versions are possible if the starting colours are right, simply by varying the time in selenium. This print also demonstrates several of the points covered in earlier chapters.

The dense infra-red negative required four stops burning-in to the top right corner in order to ensure that the colours would balance in the toning bath when the brown eventually started to appear here. As previously stated, burning-in highlights in lith prints can be difficult. This corner required nine minutes 20 seconds after a basic exposure of only 35 seconds.

The snatch-point chosen for this print was determined not by the deepest blacks as is usually the case, but by the emergence of dark tones in the water bus travelling across the picture in front of the distant buildings.

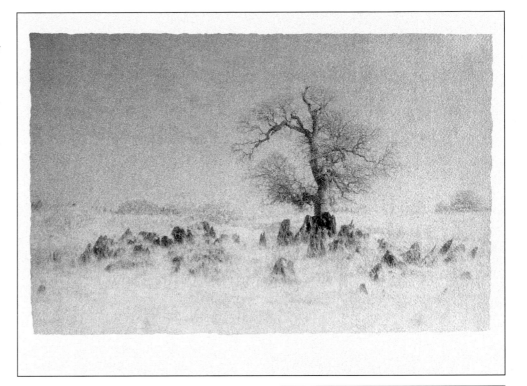

This separated the boat from the buildings tonally in the development and therefore again by colour in the subsequent toning bath. The deep shadows under the bows of the gondolas had to be dodged during the basic exposure, in order to prevent them 'completing' before the water bus was ready – I call this secondary dodging.

The print was snatched from the selenium toning bath when the browns were just creeping into both top corners, but more importantly when the water bus changed colour, and windows in the building turned blue but the walls remained pink.

How the paper is exposed is critical to all these factors as well as determining image warmth and contrast issues, that dictate the colours obtainable in selenium with these papers. With practice you will come to previsualize this at the exposure stage.

Hand-colouring – The rather more pastel colours obtained on Kentmere's Art Classic and Fotospeed's Tapestry are illustrated here in the Tree and Rocks pictures (this page) and in the Trattoria picture taken in Venice (page 69). These muted pinks, purples and browns together make a lovely background for hand-colouring, as does the canvas-like surface of Tapestry on which they are printed here.

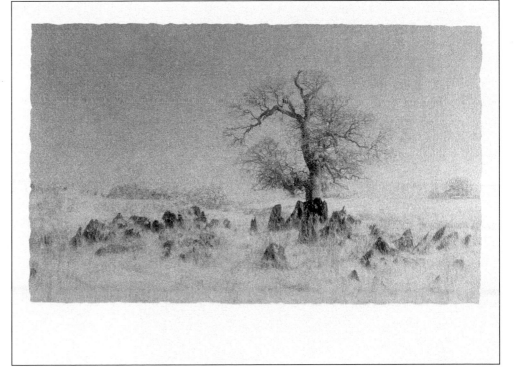

Hand-colouring can sit very uncomfortably on cold black and white tones where the colours will often jar. Split-sepia toning is therefore often employed to facilitate the integration of added colour. The subtle blending of several different gentle background colours achieved with these lith prints in selenium takes this idea a stage further and makes them the ideal medium for hand-colouring. The Trattoria print has been coloured whilst the print of the Tree and Rocks has simply been toned.

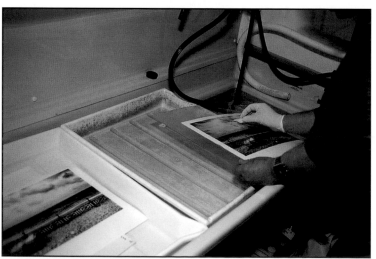

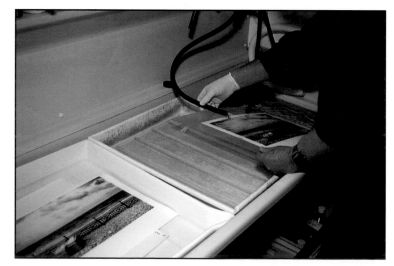

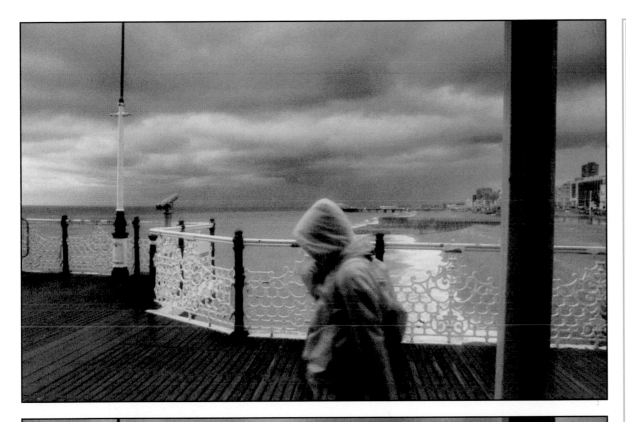

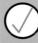

• Choose the colour to enhance the mood of the print. Often the colours seen before the end stage can be more appealing.

• Always use a wet reference print for partial toning effects.

• Soak the print well before toning. Keep the emulsion covered in the soaking tray and do not overlap prints, or patchy toning is likely. This is particularly noticeable when only partially toning in gold, as these flaws tend to even out if left in the toner past completion.

• With selenium and gold dual toning the recessive effect of blue relative to brown gives an impression of depth to the print.

• When using selenium on the multi-colour emulsions Kentona, Art Classic or Tapestry, it is possible to work on local areas of the print. Advancing an area along the colour curve can increase local visual contrast – see the clouds in the deck chairs picture (opposite page) – or direct the viewer's 'eye' as in the picture of the anorak clad figure on the pier (this page). Two different ways of doing this are shown here, there are many. Using two or three toners selectively gives an almost unlimited range of options.

• When using both selenium and gold, ALWAYS use selenium first.

• Handle prints only by the borders, avoid finger contamination and latex gloves - both can cause colour shifts at the edge of the print.

• Colours may change with 'dry down'.

The very warm emulsion of Kentmere's Kentona, Art Classic and Fotospeed's Luminos Tapestry papers are capable of striking multi-colour effects in selenium toner when lith printed. The distribution and intensity of these colours may be varied considerably by applying toner of varying strengths selectively.

In the seafront picture on the previous page, selenium toner diluted at 1+ 10 with water was applied locally to the clouds with a brush. This was hosed off frequently to avoid the appearance of tell-tale marks on the print. This had the effect of advancing the colour response locally towards blue, thus emphasising the clouds.

A similar effect was achieved with the anorak clad figure on the pier. In this case the figure was protected with a peelable varnish during the first selenium bath. When the background colour had changed sufficiently, the varnish was removed and the print returned to the selenium toner until ready.

The picture of the rocks (above) was made on Kentona and developed in hot LD 20 to produce strong orange tones (left). These responded enthusiastically to selenium of different strengths – sometimes neat – applied with a brush, to produce these vivid colours.

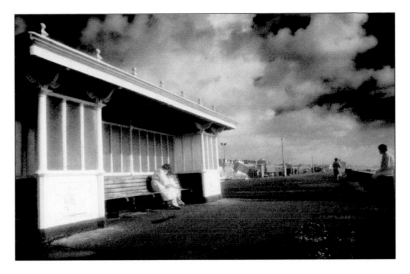

All lith prints give beautiful blue tones with gold toner, but there are significant differences between the papers, as listed in the tables at the back of this book. Some papers yield attractive intermediate colours before they are fully toned. The pictures shown here illustrate some of the colour changes seen on Kodak's Transtar TP5 when lith printed. See text for further details.

• *Transtar TP5 lith prints in Selenium Toner*

This paper also responds a little differently and will be described later in this chapter under Selenium Plus Gold.

GOLD TONER

A single solution, odourless, non-toxic, non-staining toner used without dilution straight from the bottle. Gold toners from Tetenal and Fotospeed have all the attributes you could wish for and their dunk-watch-snatch daylight toning technique could not be simpler. Their only downside perhaps is their cost – but gold chloride does not come cheap. A litre of gold toner will however tone up to 60 8" x 10" prints, or the equivalent surface area.

• *Colour Changes in Gold Toner*

Lith prints respond far more positively to gold toners than do conventional prints, producing a most beautiful clear blue that has the added advantage of being archival. A usually slight contrast increase may occur but unlike blue toners, that do this by increasing density in shadows, gold may sometimes slightly lighten highlights to give lovely open clean tones.

Initially lith prints may change colour slowly in gold toner. This is particularly true with MACO and Ilford's Multigrade Warmtone papers. Some papers initially cool off the image to greys and lilacs, others begin by warming up to pinks and magentas. Intermediate stages vary with papers and also with the image colour produced by the various processing techniques already described. These hues can be very attractive without going to a full blue. If deep browns are present in the untoned print, they can sometimes be preserved if required, as unlike selenium, the lighter tones are affected first by gold toner and the print can be taken at a blue/brown split before the dark tones change. Ultimately however, even the darkest brown will turn to blue. This split does not readily occur with MACO

> **⚠ Caution**
>
> Occasionally I see marked, even severe highlight bleaching, when workshop participants gold tone the lith prints they have made. This is generally due to over-fixing and should not occur if adequate attention is given to technique. Yet another good reason never to over-fix prints.
>
> Slight lightening may also be observed when Tetenal's gold toner is nearing exhaustion. This is possibly due to the presence of thiourea (thiocarbamide) in the toner which may still be active after the gold is used up.
>
> Thiourea may also be responsible for the lightening after over-fixing in combination with the excess thiosulphate in the print.

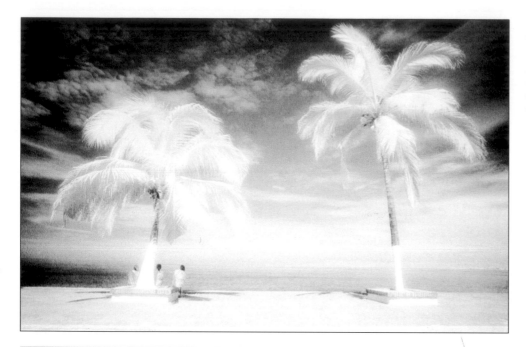

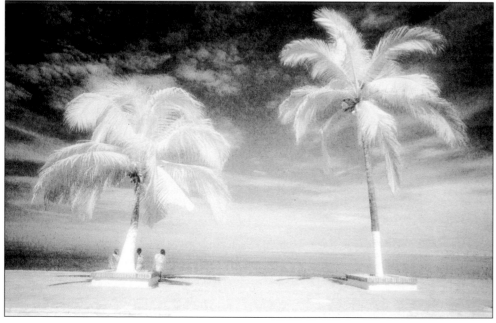

Colour is important in the way an image communicates to the viewer. The untoned Sterling Premium F Lith print (top) is a warm-tone print of a hot scene and yet the gold-toned version (bottom) works better. Despite the fact that it is a cold colour, the blue conveys the feelings of sea, sky and siesta more effectively.

papers. It is most marked with Transtar TP5 and in between is Sterling Lith paper.

The following is a general guide to the colour sequences you can expect with gold toner, bearing in mind once again that the pre–toning grain size/image colour characteristics affect the results and so considerable variations may occur.

• Sterling Lith Paper

Starting colour:	Brown.
Goes to:	Cooler greys or browns, gun metal.
Finally to:	Blue, to bright blue. Heavy dull blues in dark low-key prints.

• Kentona, Art Classic, Tapestry

Starting colour:	Brown, pink, red, maroon, orange – when dry, depending on technique. Brown, beige or golden – when wet.
Goes to:	May go more to pinks/reds depending on starting colour.
Finally to:	Purples, lilacs, mauves, then to bright blue. Dull blue in heavy dark prints.

• Transtar TP5

Starting colour:	Bright pink or pinky-brown – when dry. Caramel coloured – when wet.
Goes to:	Initially warms to pink/red.
Finally to:	Cools off, then to purples, then bright blue.

Choice of colour is usually highly subjective, but sometimes a particular colour is needed to make a print work. Left is an example. The image is all about sky, sea and a hot, sunny, siesta-like atmosphere. Pictorially it works well as a punchy black & white image, but a lith print introduces a softness in the highlights and mid-tones that is more supportive of the quiet peaceful mood, without losing the depth of black in those small but important areas (soft in the highlights – hard in the shadows). For me the brown tones of the untoned Sterling Lith print do not go with this scene – it has to be blue to work. Treatment with gold toner completely changes the atmosphere in the picture, providing a sense of light and airiness that it needed, and a colour sympathetic to the scene. Although blue is a cold colour and this is a 'hot' scene, blue carries connotations of expanses of sky and sea.

SELENIUM PLUS GOLD

A combination of these two toners can be highly effective with lith prints. The cold blue and the warm brown set each other off beautifully. Detail in busy pattern areas is accentuated, as brown, darker detail suddenly stands out from the adjacent blue tones

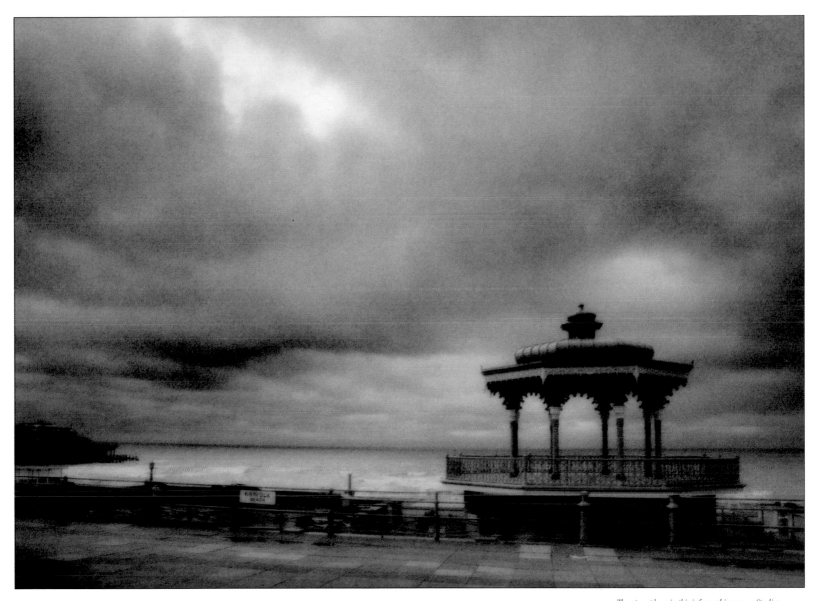

emphasising local contrast. Areas such as lace curtains, dresses, scarves, floor and wall patterns can be amazingly enhanced by this dual toning technique.

Landscapes with darker foreground tones – e.g. tree trunks – also benefit from this treatment as the brown tones stand forward, whilst the blue tones are recessive. Apart from being aesthetically satisfying, this combination can add considerable depth to a picture.

Practical considerations

There are three important things to know before using these toners together;

1). When using both selenium and gold toners on the same print, it is important to selenium tone the tones you require before using the gold toner. If you lay down the blue colour from the gold toner first and attempt to selenium tone the rest, the selenium will chase away the blue tones – and they cannot be retrieved by going back into gold.

This may seem strange as both are archival toners, but they work in different ways. Whereas selenium works by replacing the silver halide molecules, gold toner archives by coating them with a colloid of gold. The gold itself is not blue, but the silver when seen through the gold

The atmosphere in this infra-red image on Sterling Premium F Lith paper has been enhanced by diffusion under the enlarger and gold-toning. The subdued colours obtained by toning, first in selenium and then only briefly in gold, are more appropriate to this scene than would be the bright blues of the previous picture.

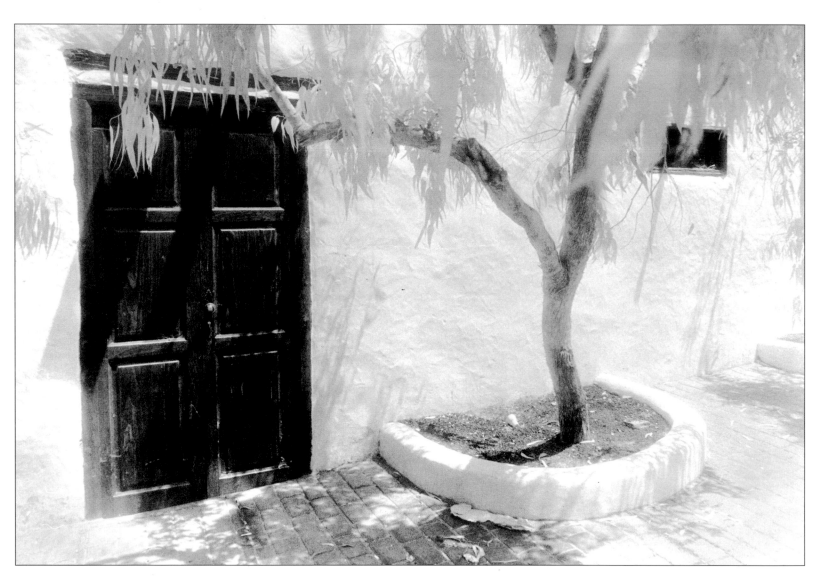

This untoned Sterling Lith print has an inherent beauty with the soft creamy nature of light tones juxtaposed with the cold hard characteristics of the shadows. However, such pictures offer the printer many colour combination options with just two or three simple-to-use standard toners. A list of suggestions using this picture as a model is given in the main text.

colloid appears blue. Selenium toner has the ability to get past the colloid to the silver halide underneath and change its colour, which is visible through the colloid. This is therefore irreversible and returning the print to the gold toner will not reinstate the blue colour.

This is presumably a similar mechanism to that which is responsible for the pink or red colours seen when gold toning is applied after sepia toning in a conventional monochrome print.

2). The take-up of selenium in the dark tones can sometimes be difficult to judge depending on the colour of the untoned print, but this gets easier the more you practice.

It is easily visible on Kentona, Art Classic and Tapestry because of the great colour shifts. In practice it can be difficult to get a clean split between the toners, because there are several colour stages before the print finally reaches the end point of selenium brown.

Sterling Lith paper is more difficult to assess, as the starting and finishing colours in selenium can sometimes be similar. If the toner is dilute, the colour change is gradual and easy to miss. Until experienced, timing a test piece through both toners sequentially is the safest way to predict the result in important work.

Transtar TP5 is the easiest paper to assess and gives the cleanest blue/brown split. Disregard the initial light tone colour shift in selenium and concentrate on the near blacks. Wait for them to change to the typical selenium brown colour, then wash and transfer to gold. The effect varies according to how far up the tonal range the selenium is allowed to go.

3). Both toners are expensive – but especially the gold as it is used undiluted. It is essential to thoroughly wash prints between these toners – at least 30 minutes for fibre prints – as selenium carry-over and contamination will ruin your costly gold toner in short order. Transtar TP5 being a resin paper needs only a five minute wash between toning stages.

SEPIA (THIOCARBAMIDE)

Usually referred to as variable sepia or variable colour sepia, this toner consists of a bleach bath, followed by a separate toning bath and can produce colours varying from yellow to deep rusty-brown.

Generally more interesting effects can be achieved by diluting the bleach. As the bleach works first on the highlights, the print can be removed when only the lighter tones have been affected. The subsequent toning bath then only tones these lighter values where the bleaching has taken place.

This is marginally interesting on Sterling Lith paper and slightly more so (brown over pink) on Kentona and Tapestry. The more interesting effects appear when the print is subsequently (after washing) transferred to gold. The thiocarbamide-toned high values now change to yellow, salmon or pink whilst the lower values go blue as normal for a lith print in gold toner. This can be very subtle and quite lovely especially in light delicate prints.

This colour change through the gold colloid is presumably similar to the effect noticed with selenium as described earlier. If attempted on a lower-key red Art Classic/Kentona print, the blue may be too heavy and can overwhelm the input from the sepia.

As selenium works first in the dark tones and sepia in the highlights, this gives a tremendous degree of colour control. For example, the following options would be available on the print of the Tree and Door opposite.

Brown tree.	Blue wall.	Partial selenium, then gold.
Brown tree.	Pink wall.	Partial sepia, then partial selenium, then gold, or partial selenium, then partial sepia, then gold.
Blue tree.	Pink wall.	Partial sepia, then gold.

NB – A rich pink is more difficult to achieve this way on Sterling Lith paper than with sepia/gold toning on a conventional print. A salmon-pink is more usual.

> The reactions to selenium and gold toners of all these papers described is typical for the conditions written up. The colours obtained however are heavily dependent on the original lith processing. All the variables described in detail in the previous chapter can have an effect on the way the print responds and wide variations outside those described here are possible.

Money Saving Tip – Home made variable sepia toner is easy and saves money. Firstly, the ingredients all have other valuable uses in the darkroom and so you should have them anyway. Secondly, you mix the quantities you require.

If you buy a kit, you will always still have half the bleach and the additive left over when you need to buy your next kit!

Sol. A – Bleach

Potassium ferricyanide	100 gr
Potassium bromide	100 gr
Water to make	1 litre

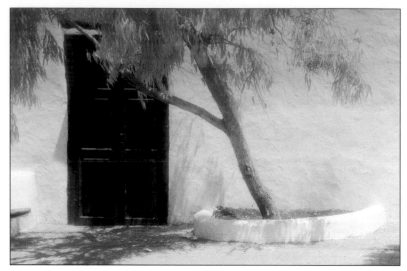

Although Litho-print is not a true lith developer, it can produce colourful prints that very closely resemble prints made in lith developers. As shown here, these colours can be varied from soft browns to bright oranges, reds or maroons by the processing technique, as explained in the text. These prints respond very positively to both gold and selenium toners as would be expected from a lith print. Strong intermediate colours can be particularly attractive.

Sol. B – Toner

| Thiocarbamide | 100gr |
| Water to make | 1 litre |

Sol. C – Additive or Activator

| Sodium hydroxide | 100 gr |
| Water to make | 1 litre |

NB – Add sodium hydroxide slowly to water – NOT the other way round.

The bleach may be further diluted for use, if partially bleaching for split-tone effects. Try between 10% and 30% according to delicacy of print and personal preference.

The colour achieved in the toner (Sol. B) can be varied according to how much 'additive' or 'activator' (Sol. C) is added. The following is a guide;

Sol. B Toner	Sol. C Activator	Water	Colour
5 parts	1 part	50 parts	yellow – sepia
4 parts	2 parts	50 parts	sepia
3 parts	3 parts	50 parts	mid-browns
2 parts	4 parts	50 parts	cold or rust-brown
1 part	5 parts	50 parts	purplish-brown

• Solutions for lighter brown tones are more likely to lead to some loss of highlight density and tone more slowly.

Lith prints on Ilford's Multigrade Warmtone are less colourful than the other lithable papers, giving images in ivory and black tones. These prints do not at first appear to respond very positively to gold toner – certainly when compared with the other papers so far discussed. Patience pays off however, and eventually strong blues are achieved – although of a less vibrant hue.

The print on the left illustrates this – the left half was gold-toned for 30 minutes instead of the usual 5-10 minutes used for many other papers. This is an apt reminder that all papers do not behave the same and that their individual characteristics must be learned.

- Solutions for darker brown tones exhaust quicker and tone faster.
- Mix all toning solutions immediately before use.
- Bleach solution keeps well for long periods if stoppered in dark glass bottles.

Litho-print revisited

In view of its different mode and style of action to the true lith developers so far described, Litho-print merits some separate discussion and this might be the appropriate place to consider it, as prints made with it do respond well to these toners.

This developer was described in Chapter 2 (Equipment and Materials). It is not a true lith developer and was designed principally to avoid pepper fogging on Sterling Lith paper – whilst retaining typical colours – and to produce colourful effects with other suitable papers.

The instructions recommend a 1 + 9 dilution for use and as always in lith printing, this should be regarded as guidance from which you should feel free to depart and do your own experimentation.

In use it is immediately obvious that it is a very different product to the usual lith developers and I found it required quite a different technique to that of conventional lith printing to get the most out of it. Induction is quite slow as with the higher dilutions of true lith developers. The image builds up quite slowly but in a more linear fashion – there is no terminal rush as with infectious development. Both highlight and shadow tones continue darkening as development proceeds – unlike normal lith printing, where highlights are a product of exposure rather than development. The ratio of one to the other is however affected by exposure, thus allowing some control of contrast via exposure.

Prints on Sterling Lith paper were similar to the usual Sterling lith colours, but could be varied from an olive sepia to the pinkish sepia that the original (pre-pepper fogging) Sterling Lith paper used to give. The prints showed no hint of pepper fogging with clean, creamy highlights. They were overall slightly less 'lithy' looking, as shadow detail was well preserved, resisting the usual blocking up for much longer. This made control and snatching easier and more leisurely but without the range of extreme contrasts being available – but how often do you need grade six or seven?

Kentona paper produced an impressive range of lovely colours in this developer, ranging through cream to gentle browns, pinks and lovely strong reds. The best technique for producing the stronger colours I found was to over expose by an additional one or two stops and allow the fix to bleach-back as described earlier (see Turbo fix-up). Judging the development of the blacks in the dark looking prints is just a question of practice. The temptation is to pull too early as the print looks too dark – this will give a low contrast image in soft pinks. Interestingly, the borders remained commendably clean long after they would have fogged heavily in true lith developers.

Toning in selenium and gold is particularly impressive with the stronger colours and I especially like the very early changes of the rich, red prints in selenium, and the selenium/gold splits, that can be varied anywhere along the blue/purple/mauve spectrum.

I think you will agree that the prints in this chapter have been very different to the straight lith prints in the opening chapters, showing something of the creative and expressive potential of the lith printing process – moving as it does away from photo realism into what one might call representational photo art.

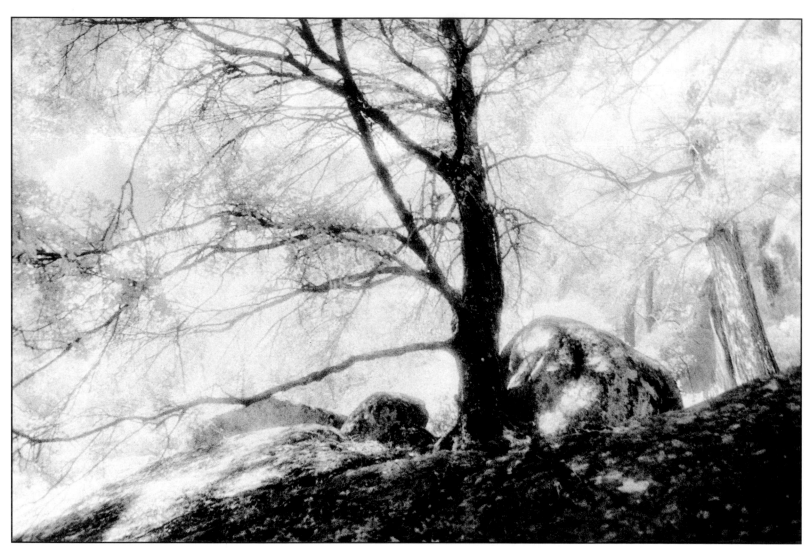

Dual-toning in selenium and gold can be very attractive. The selenium adds depth to the darker tones whilst the gold gives a light, airy blue to the light tones. Blue is recessive to brown and this can add depth to a picture. The selenium should always be used first and the print well washed before going into the gold toner. The above print was made on Kodak's Transtar TP5 which is the easiest lith paper to dual-tone as it splits convincingly and obviously.

Lith prints can be made – as here – using colour negative stock as well as conventional black and white materials. Colour negatives often offer finer-grain characteristics which the lith process can exploit. The multicolour effects here were achieved by using selenium toner on Kentmere's Kentona paper, removing peelable varnish masks at suitable stages of the toning process.

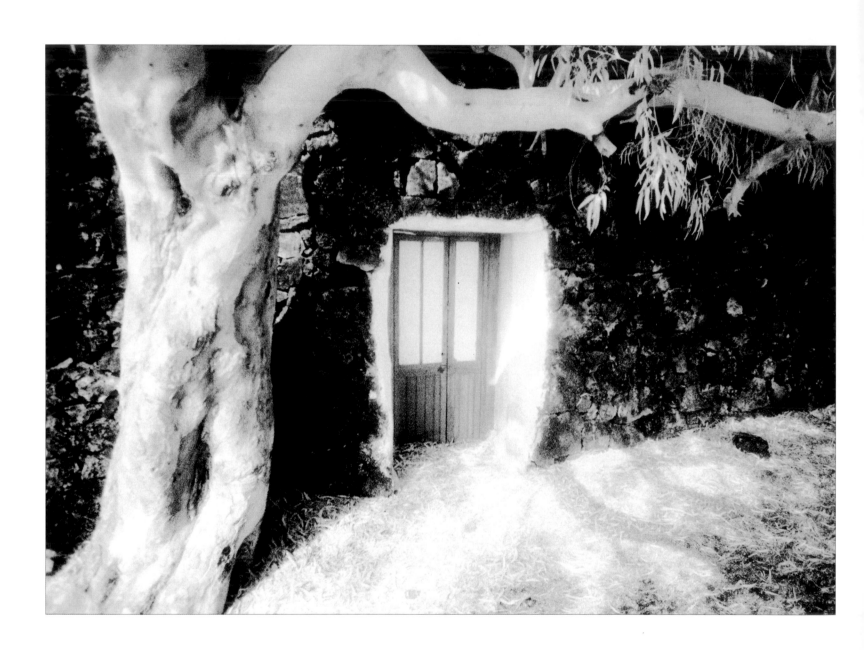

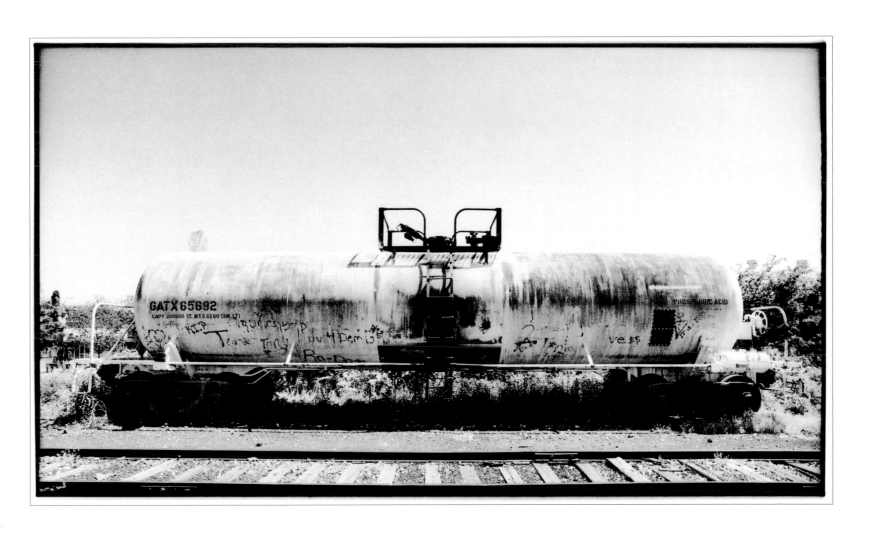

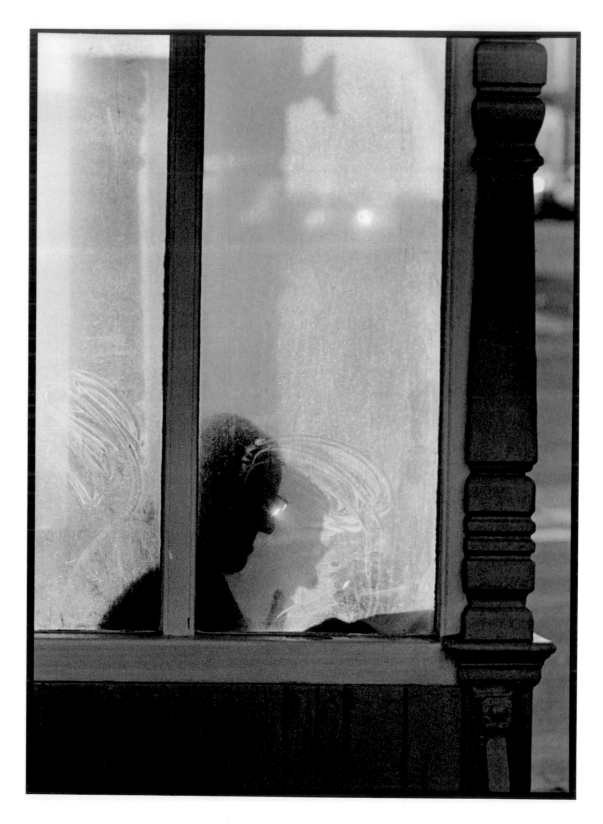

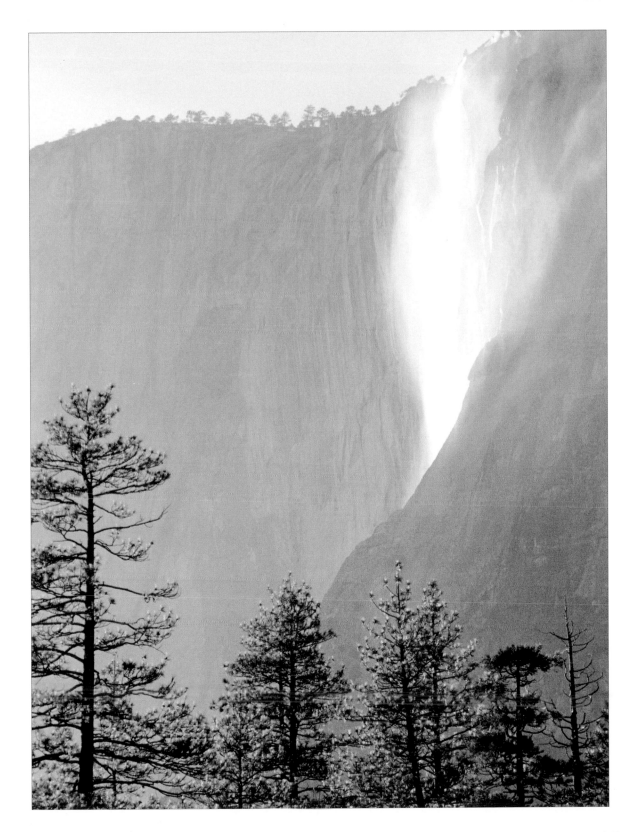

Chapter 9
Bleach and Re-development Games

In this Chapter:

- *Extra colours without toning*
- *Additional choice of useable papers*
- *Factors affecting outcome*
- *Some like it hot!*
- *Choice of bleach*
- *Special effects with silver and gold*
- *Alternative bleach, fixer and hypo-clear formulations*

If like me you regard your darkroom as a playroom, you can have a lot of fun with bleaching and re-developing your prints in lith developer. The resulting colours come without the use of toners and can be either vivid or gentle, but other unusual effects are also possible. Results vary enormously with different papers, bleaches and developers, as well as with technique, and a large number of otherwise unlithable papers can be used. The permutations available are too many to cover comprehensively, but this chapter will give you an insight into some of the techniques and their results.

BE SURE, YOUR SINS WILL FIND YOU OUT!

Although the procedures involved are no more difficult than ordinary print processing and sepia toning, I warn you that if your working technique is poor or sloppy, this will really show it up in the form of streaks, blotches and uneven colours that all appear out of nowhere during the second development. Many of these faults would eventually disappear if the second development was taken to completion – but the whole point of re-developing in lith is to give only partial development, as in normal lith printing.

A print that has been thoroughly cleared of fixer can be bleached away and brought back again in the same or another developer – in exactly the same way as it is bleached and re-developed with a sepia toning kit. As with sepia toning, this is all carried out in daylight.

THE EASY OPTION...?

It might therefore seem logical to make a print in the conventional way in ordinary print developer, bleach it back in a potassium ferricyanide/potassium bromide bleach, and then make it into a lith print in lith developer. This re-development could be carried out with the lights on so that you might see the infectious development progressing and judge the snatch-point easily. I have seen this written up as an alternative – or even an easier – technique for producing standard lith prints. I do a lot of bleach and re-development work, and I have generally not found the results of this to be as good, or as controllable, as lith printing from scratch, if I want a true lith print. I certainly remain generally sceptical about it as an easy alternative to producing

Some do, some don't. Not all papers will produce acceptable lith prints by bleaching after normal development and re-developing in lith developer. Forte Polywarmtone is one that does. The top picture is a lith print on Forte Polywarmtone developed in MACO LITH developer to produce the pinks on browns typical of lith prints on this paper. The print below shows the same paper developed in Ilford Multigrade and re-developed in MACO LITH developer after bleaching in ferricyanide/potassium bromide. This produces very similar pinks on browns although the dark tones are smoother and less grainy. There is some loss of highlight detail that must be anticipated in the printing. The bottom left corner shows the early emergence of soft greys. If the second development is extended, this will produce a pink/grey split across the tonal range.

straight lith prints with most papers. The technique and the printing controls are quite different – nothing wrong with that of course, as long as one appreciates the fact – but the results, too, are different. They may be coloured, with a resemblance to the lith counterpart, but there are always differences that may or may not be important.

Ilford Multigrade FB Warmtone lith prints best in hot lith developer, where it produces ivory hues. On bleach and re-development it can yield a variety of different results, one of which is shown above and looks much more like the expected tones of a normal lith print.

These may be in terms of colour, contrast, adjacent hard and soft qualities and the response to toners. With some materials, and this includes many of the liquid emulsions and linen based emulsions as well as some papers, the colours even disappear on fixing. This can be very frustrating after the long procedures leading up to this point.

Provided that one takes these differences into account, there are notable exceptions where this technique works very well. Forte Polywarmtone is a good example and is illustrated opposite together with its lith counterpart. Although similar, it will be seen that significant differences exist and of course the printer, to produce the desired effect in any particular image, should exploit these. Ilford's Multigrade Warmtone is another good example, and indeed as is shown here, the bleached and lith re-developed print looks superficially much more like a lith print than does the real thing on this paper!

...OR THE CREATIVE OPTION?

However, by using this process one may end up with a result that is quite different and can be equally or even more interesting depending on the materials used.

For example, both these two papers discussed above can be made to yield completely different results to those shown so far, just by changing the technique used. Had the Polywarmtone been pulled later from the second developer, the grey seen creeping into the bottom left hand corner of the pony print (opposite) would have continued to build up. The print could then be pulled at a lovely pink/grey split similar to that shown with Kentmere VC in the series of the tree standing in a Scottish loch (overleaf). The Multigrade FB Warmtone version of the same tree, on the other hand, has now been processed to give soft yellows and black. Kentmere's Kentona produces impressive colours in browns and greys as shown here and is consistent, and easy to predict in its processing.

The best lith printing papers do not necessarily give the most interesting results with this technique. Sterling Premium F Lith for example is definitely best used for first-pass lith development. Several non-lithable papers on the other hand perform very well on second-pass lith development. All paper types are therefore worth experimenting with. In addition to some of the papers already mentioned, good colours can be obtained with

Tip

It can be disappointing to see the colours after re-development fade in the fixer. Sometimes they lighten, sometimes they all but disappear – different materials behave in different ways.

Although it can be tempting to leave the print unfixed to preserve the colours, this will only suffice for the short term as the print will change over a period of time with silver staining taking place.

Colour loss can sometimes be minimised (not avoided) by using weak hypo or one of the following modified fixer formulae instead of the more aggressive rapid fixers. My tests show that this helps with some materials but makes little difference with others.

Alkaline Fixer:

Water	750ml
Sodium thiosulphate	60gr
Sodium carbonate	3gr
Water to make	1litre

(The amount of sodium thiosulphate in a litre of simple or acid fixer is usually in the region of 250 - 300gr).

or try:

Water	750ml
Sodium thiosulphate	100gr
Table or cooking salt	a handful
Water to make	1 litre

(As suggested by Speedibrews)

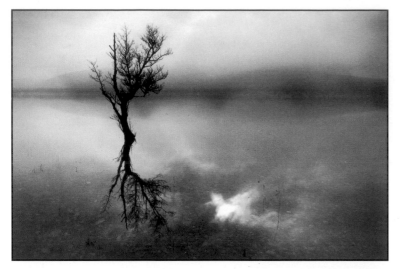

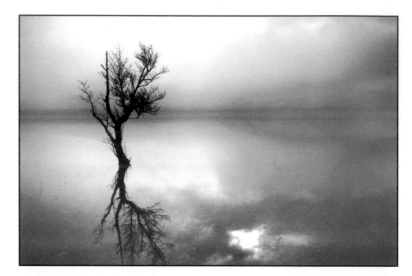

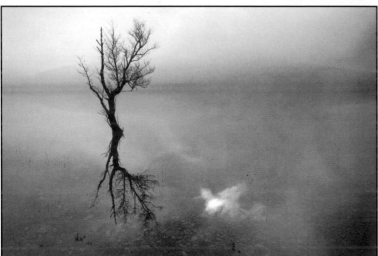

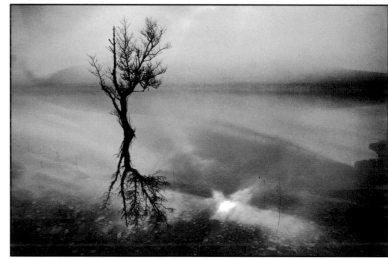

Secondary lith development after bleaching offers the printer a range of colourful effects, that are determined by the choice of paper and the printer's technique as described in the text. The top left print shows the typical soft pinks and greys given by Kentmere's Fineprint VC whilst the top right image illustrates a different interpretation with Ilford's Multigrade Warmtone FB. The bottom left picture shows soft browns and greys which are easily produced by Kentmere's Kentona. The final image shows similar colours with Agfa Multicontrast together with the type of streaking which may appear on re-development, if the initial development was uneven.

Kentmere VC (Select or Fine Print), Agfa Multicontrast Classic and several others. Especially interesting however are Sterling's FB VC and Pro RC VC for a variety of effects as illustrated later in this chapter.

CONTROLLING THE OUTCOME

Apart from the paper and bleach used, technique is the factor most influencing results. Of particular importance are;

a). the exposure – the density of colour is proportional to the exposure given. Over exposure yields stronger colours. Try a series at $^1/_4$ or $^1/_2$ stop increments.

b). the time in the bleach – results may be strikingly different if only the light and mid-tones are bleached

away, leaving the blacks intact (use diluted bleach for this) than if the whole image is bleached away.

c). the time in the second developer – colour is closely related to grain size, that in turn is determined by the stages of development. The Golden Rule still applies in the second (re)development.

Some like it hot!

In some of these bleach and re-development games it pays dividends to increase the temperature of the second lith developer to between 30˚C and 40˚C. There is no right or wrong here, so experiment. Some papers perform in different ways across the temperature scale.

The four untoned pictures of a tree in water above, illustrate some of the colour effects of the same process

with just a few different papers. The procedure is as follows;

After normal processing, fixing, hypo-clear and washing, bleach a slightly over exposed print back in about $1/3$ strength bleach from a sepia toning kit until all light and mid-tones have gone but the blacks remain. Wash and develop in dilute lith developer at around 30°C (not critical).

The mid and, eventually, the light-tones will yield a choice of bright, warm colours before ultimately changing to cool-bluish tones as development continues, and grain size increases. Eventually these will change to greys similar to those with which you started. Darker prints with say $1/2$ to 1 stop over exposure can give deeper and stronger colours. Lighter prints of 'normal' exposure give more pastel hues, although highlights may need to be protected by giving an extra $1/4$ stop exposure.

With practice the results are very consistent, being very much determined by your technique and as always with re-development games, the processing must be faultless. As the second development should be incomplete in order to obtain these colours, the final print will always be lighter – particularly in the highlights – hence the over exposure, the degree of which varies with the make of paper being used. It can often pay to give some extra exposure to prominent highlight areas for this reason and if using a VC paper it helps to add this extra exposure through a low contrast filtration.

The final colours depend on when the second development is stopped, and a mixture of the colours can be obtained. Kentmere VC, Select and Fineprint papers give lovely pinks and greys – or reds and blacks in dark sombre prints. Forte Polywarmtone can yield a lith look-a-like print with delicate pinks and browns before going onto a pink/grey split if the development is allowed to slowly continue. Multicontrast Classic gives oranges and mauves, whilst Kentona gives browns and greys with hints of maroon. Colours lighten and may change dramatically on fixing, either becoming more vivid in striking yellows and pinks, oranges and browns or they may fade. These colours often change completely again when the prints dry and with some papers may, annoyingly, even almost disappear!

The Bleach

Changing the bleach may also influence the colours in the final image. The textured wall and drainpipe picture (above) was bleached in a cupric sulphate and sulphuric acid bleach. This produced very similar dry down colours on Kentona, Fortezo and Polywarmtone. The latter two have more brilliant colours although the differences are more apparent when wet. The colours

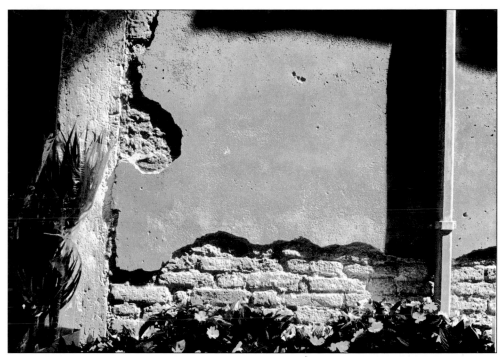

The colours shown here on Forte's Fortezo paper are similar to the bleach and lith re-development colours of Kentmere's Kentona, but as a cupric sulphate bleach was used they are more vivid. The ratio of orange, grey, white and black can be varied by the processing technique. See text for details.

are similar to those obtained with the ferricyanide/bromide bleach-back technique in the next chapter but much more orange and vivid. I am not aware of this bleach being commercially available but the formula I use is found at the end of this chapter.

Colour–Silver Split

Although not normally lithable, Sterling Pro RC VC and Sterling Premium FB VC both produce exceptionally vivid results with several bleach and re-development procedures, and are remarkably consistent and easy to use. Examples of this with both partial and full bleaching are shown on the next page.

Partial Bleach

The first picture (overleaf) of the Venetian doorway and boat was bleached-back to, but not including, the blacks using a dilute ferricyanide/bromide bleach. On re-development – in Novolith in this instance – vivid and striking colours emerge. As development proceeds, a silvery-grey starts to sprout in the mid-tones. This happens quite suddenly and is very striking to see. These silver-greys expand until the print is moved to the stop or water bath. If left in the developer, the entire print changes to this colour. Here the print was pulled to give the colour and silver side by side. An earlier snatch would have given vivid colours alone – a later one all silver-grey. This effect is quite different to the mono-with-a-dash-of-colour-in-the-highlights effect that the previously demonstrated papers can give. It has a chemical solarisation appearance.

Tip

As the print approaches the snatch-point in the second developer, rather than transfer it to a stop bath, move it to a running water bath, where it will continue to develop but more slowly and evenly, giving you greater control. If dissatisfied, you may develop further in small stages transferring back and forth between water and developer, or bleach-back again. Finally re-fixing is needed, whereupon it may change completely anyway – depending on the paper being used!

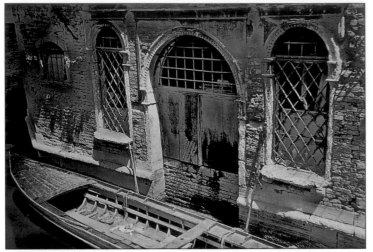

A.

B.

C.

D.

E.

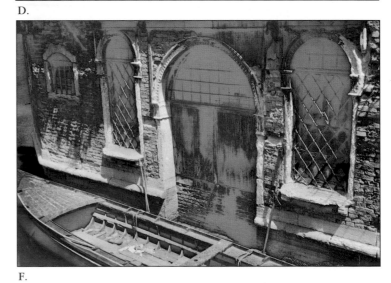

F.

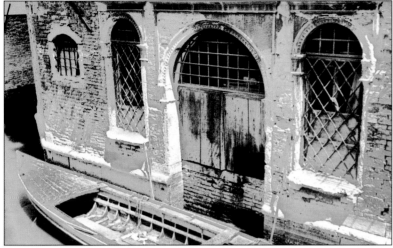

G.

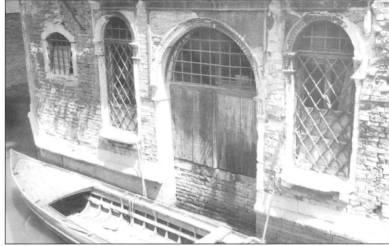

H.

A significant amount of colour loss does inevitably occur both in the fix and, to a much lesser extent, with these two papers on dry-down. This can be seen by the vivid colours in the transparencies (images A., D. & E. opposite) taken before the prints were fixed.

Full Bleach

If the same papers are fully bleached-back until all the blacks have gone (full strength bleach is quicker but not essential for this) and then re-developed in lith developer, a completely different effect is achieved. Here the blacks remain as orange on re-development. The transparencies (D. & E.) illustrate the progression you would have seen in the developer (this is in normal day or room light) in the stages before the print was pulled. Sterling's Signature paper also produces orange blacks this way, but they subdue more on drying and are placed in a more monochrome looking range of tones, suggesting a glow inside the building. An orange tree in the lake, however, looks decidedly odd, so you have to match the trick to the image – as always.

Other papers can produce these orange-blacks but Sterling's RC VC and FB VC are the easiest and most vivid I have found. Kentona can give similar results if both first and second developments are in lith developer. This is quite different to the striking bright orange that comes on Forte's Polywarmtone and Fortezo with lith development after cupric sulphate split-bleaching. In these latter papers the orange sits alongside grey, but in addition to the black that adds depth and solidity to the picture, Kentona gives similar but less brilliant colours.

Holding the colours

As the shot of the wet pre-fix print (A.) shows, the colours are much more vivid before fixing. I have tried a variety of fixer formulae in an attempt to preserve the colours but none appear to be wholly effective. The weak warm-tone fixer and the thiosulphate/salt formulae shown in the Tip Box on page 93 produced less colour loss than strong Hypam type fixers.

The print can of course be left unfixed, but as it will still contain silver salts, prolonged exposure to light is likely to break them down in the long term with consequent silver staining.

All that Glitters

Another striking metallic effect is seen with Sterling's RC VC and Premium FB VC, and with Kentmere's Kentona using gold toner.

The initial print should be $^1/_4$ to $^1/_2$ stop over exposed and processed in a conventional print developer. After hypo-clear and washing, it is partially bleached preserving the blacks. This should be now re-developed in warm, used Novolith or LD 20, but pulled very early as the highlights go a pale golden yellow. If this is transferred to gold toner, the print will eventually show a mixture of metallic gold, silver and greys. Very striking – but impossible to reproduce on the printed page. This effect is sometimes helped by giving only a light fix after the first development.

Kentona gives a similar effect but not so readily. In this case a full bleach-back is given, followed again by only a partial development before transferring to gold, where it may need to stay for quite a long time.

Ilford Multigrade Warmtone – hidden secrets

Earlier in the book I looked at how this paper responds to being lith printed. Although best is always a subjective term, for me the best results with this paper

The images on the opposite page are all on Sterling RC VC. Premium FB VC produces identical results.

A., B & C. were partially bleached, sparing the blacks. D., E. & F. were bleached to completion. A. shows the vivid colours seen before fixing compared with B. which has been fixed in an alkaline fixer (see formula in Tips box on page 93). C. shows the effect of extending the second development allowing progression of the grey. D. & E. show the progression seen in the second development after complete bleaching but before fixing. This can be followed easily in normal room lighting. F. shows the print after final fixing.

Above. These two images, G. & H., show some of the effects of gold toning after re-development in lith developer. G. shows Sterling RC VC, three quarters bleached and toned after re-development. H. illustrates Sterling Signature fully bleached and gold-toned after partial re-development.

Metallic gold and silver effects are also possible as described in the text but difficult to reproduce on the printed page.

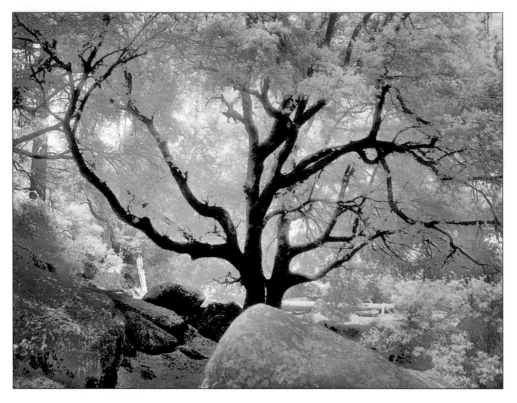

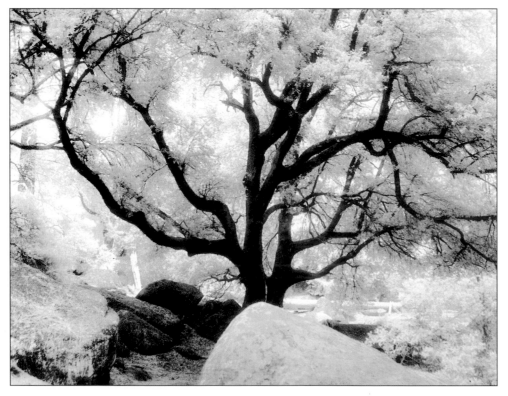

are obtained in developer that is both mature and hot. Although quite different to its appearance in normal processing, when lith printed it lacks some of the impact of the other emulsions used for lith printing, both in graphic and colour effects. But of course there are always images that require a more understated interpretation.

Having said that, Ilford's Multigrade Warmtone FB paper can be persuaded to reveal hidden secrets with lith developer when used with bleach and re-development techniques. As we have seen earlier in this chapter, it can give lith look-a-likes or soft gentle yellow browns against black. It can also be persuaded to offer up a variety of mixed colour effects and even emulate the brown/grey solarisation effect of Sterling's RC VC, albeit with more subdued results.

After a complete bleach in a ferricyanide/potassium bromide bleach, similar to those supplied with sepia toning kits, a Multigrade Warmtone FB print developed first in Multigrade and secondly in Novolith, or FD 20, can yield a warm-tone effect in the shadows – brown on grey mid-tones – rather like split-selenium toning. In Kodalith concentrate I get the typical lith print appearance shown earlier in this chapter.

If the bleach is only partial however, lovely soft pinky-beige mid-tones separate deep purple-black shadows from white highlights. Colours vary as always with the degree of bleaching and the amount of development permitted in the second developer.

Even more variety is obtained by changing the bleach. I particularly like the effect of Ilford Multigrade Warmtone when processed in Multigrade developer, fully bleached in cupric sulphate/sulphuric acid bleach (formula opposite) and brought back in hot lith developer.

The colours are similar to the above but the shadows are bluer and the mid-tones pinker. Split-bleaching with this bleach may give all blue or all brown tones, brown shadows and blue mid/light tones – or blue shadows and brown mid/light tones – it's all in the timing, both in the bleach and developer.

Different again and quite varied results can be obtained by making the first development in a lith developer, Kodalith and Novolith giving different end point colours. For example, vivid browns on purple blacks with the former, and soft browns on greys with the latter. Bleaching with cupric sulphate bleach and re-developing in hot lith now will give rich red-browns of a much more vivid nature. The choice of colour and effect is limited partly by the materials but also to a considerable extent by the printer's imagination and willingness to experiment.

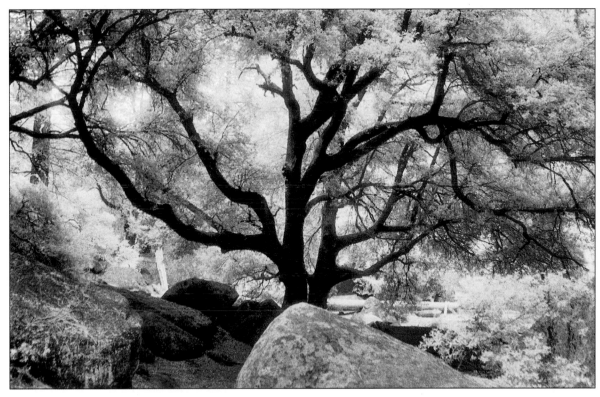

Ilford Multigrade Warmtone can be persuaded to reveal hidden secrets and a substantial range of colour combinations when re-developed in lith developer after full or partial bleaching in different bleaches. The three pictures here were bleached in cupric sulphate/sulphuric acid bleach and re-developed in Novolith to give different combinations of greys, browns and purple. Many other coloured effects are also possible.

 Caution

It is essential to understand the difference between reversible bleaches such as potassium ferricyanide (ferri), and Farmer's solution which is ferri + hypo fixer and is irreversible.

It is vital that with re-development techniques **all** fixer is cleared from the paper, or it will react with the bleach to form Farmer's solution (or similar if other bleaches are used) and this will prevent full re-development.

Fibre based papers need special care to clear fixer products from the fibre base from where they may otherwise leech into the emulsion.

Fresh fixer should always be used — possibly in a second fixing bath — as old fixer contains insoluble fixer salts which as they are insoluble in water, cannot be washed out.

I recommend a hypo-clearing bath before the final wash. I use a Nova Archival Washer preceded by a modified unit containing a hypo-clearing solution, see below.

One or two slot units can also be used as upright fixer baths to save wet bench space.

Stock cupric sulphate bleach for re-development

Cupric sulphate	50gr
Sulphuric acid concentrate (CARE!)	6.50ml
Sodium chloride	50gr
Water to make	1 litre

NOTE: Always add strong acids to water (slowly) — never the other way round.

For use I dilute to 10% to make partial bleaching more controllable.

Bleaching is initially slow at 10% but suddenly proceeds rapidly.

Hypo-clearing baths

A variety of simple home made hypo-clearing baths can be easily and cheaply made up. In fact, it has been suggested that adding almost anything to the wash water will help — except fixer of course. River water has been used and certainly sea water has been shown to be much more effective than tap water, providing that there is a final wash in fresh water. The addition of most alkalies to a pre-wash bath will help by raising the pH to about 9.

If you don't live on a boat, the cheapest solution then is common salt — sodium chloride, followed in increasing efficacy by sodium bisulphite, sodium sulphate, sodium carbonate and finally, one of the easiest and most effective uses of a chemical that you will already be getting in stock to control pepper fogging, sodium sulphite.

This is superior to all the others and works not only by raising the pH as a mild alkali, but also through an ion exchange, whereby it replaces the thiosulphate ions in the print with sulphite ions. These are more easily washed out by water.

Around 25gr, or a well heaped tablespoonful, of sodium sulphite per litre of water is accurate enough.

Chapter 10
Lith Look-A-Like Effects

In this Chapter:

- *Sodium hydroxide enriched developer*
- *Split-thiocarbamide toning*
- *Bleach-back effects*
- *Bleach 'n' Tone effects*
- *Final thought*

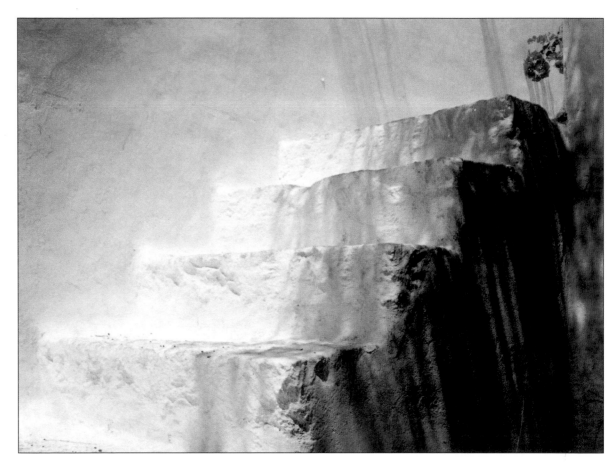

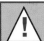

Caution

Sodium hydroxide is usually purchased in pellets or 'sticks'. These are caustic and can cause burns, so they should not be handled with bare fingers.

Having covered most aspects of lith printing, it is perhaps appropriate at this stage in the book to look briefly at a few non-lith printing techniques that can give attractive colour effects in monochrome prints with certain superficially similar properties to lith prints, i.e. white highlights, black shadows (if required) and coloured mid-tones.

These are not a quickie alternative to lith prints, as here the similarity usually ends. The hallmark qualities of soft in the highlights and hard in the shadows, the response to toners, flexibility of contrast and the re-development effects are replaced by the characteristics of the alternative technique. These can also be very attractive – but they are different.

SODIUM HYDROXIDE ENRICHED DEVELOPER

As we have seen, lith developers are highly alkaline. The alkali responsible for this is often sodium hydroxide. If sodium hydroxide is added to a standard developer such as Ilford's PQ Universal, the pH can be raised and this we know increases developer activity, as well as its oxidation (see Chapter 6, Lith Printing Advanced Class).

Prints developed in such a brew may show colours in the mid-tones between black and white. These are not

true lith prints. The colours are distributed differently and development is not infectious, but nevertheless the results can be interesting and worth pursuing.

If the developer is diluted and the paper over-exposed by up to one stop, a very soft overall warm tone print can be achieved, that is reminiscent of an old or antique photograph, although made on modern materials. This is illustrated in the print above.

The recommended amount of caustic soda to add for these techniques is 5gr per litre of working strength developer. As always, results vary considerably with the papers and developers used, as well as the technique, and there is always room for experimentation.

Note that sodium hydroxide enriched developers do not keep well due to the increased rate of oxidation. They should only be made up immediately before use.

SPLIT-THIOCARBAMIDE TONING

Thiocarbamide toners are sepia toners of the odourless variety and are nearly always marketed with an additive (sodium hydroxide again) as a variable sepia toner. This means that depending on the amount of additive used, the print colour can be varied from yellow through sepia, to deep rust or chestnut-brown.

The formula for making this type of toner is given at the end of Chapter 8 (Toning Lith Prints) and it is extremely simple to make.

The soft 'antique' look of this print was achieved by over exposing the negative by one stop onto Kentmere Kentona paper and developing in sodium hydroxide-enriched PQ Universal developer, as described in the text.

The print on the facing page was made on Ilford's Multigrade FB paper with a normal exposure and developed in sodium hydroxide-enriched Multigrade developer. The muted colours are less pronounced than in a lith print and the development is not infectious.

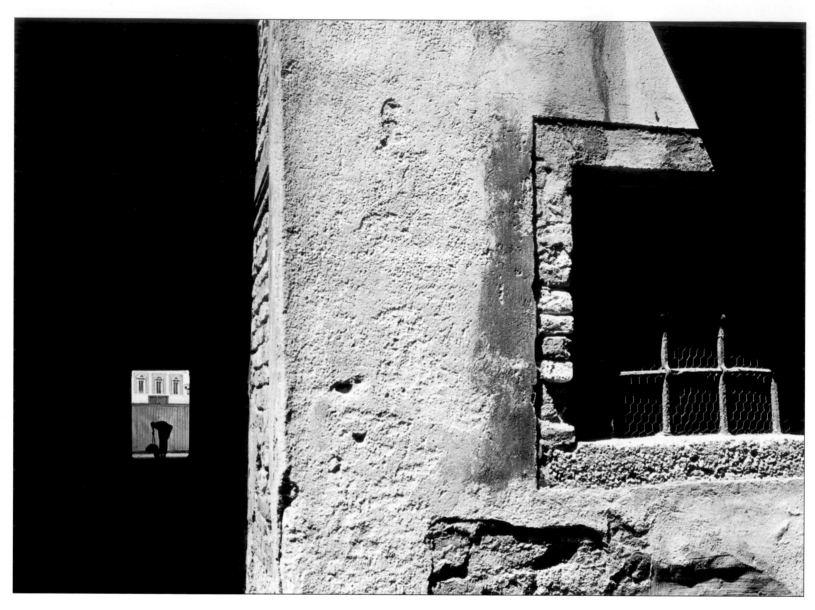

Split-thiocarbamide toning can produce results that are superficially similar to lith prints, with brown tones between black and white. Split-grading is often helpful with this technique as described in the text.

In normal day or room light, the sepia toning bath is preceded by the bleach bath. The toner then re-develops the bleached image in much the same way as the re-development techniques discussed in Chapter 9 (Bleach and Re-development Games), but unlike those processes the re-development here in sepia is not curtailed, but is allowed to proceed to completion. Instead the control is applied at the bleaching stage.

Should I go all the way?

Although the instructions in these toning kits often advocate bleaching the image all the way back to give a complete sepia effect in the toner, it can be more effective to split-tone by only partially bleaching before toning. In practice, the bleach appears to work preferentially on the highlights first and the shadows last. In fact, it probably works equally on all tones (probably because dilution can effect this property of ferricyanide bleaches), but whereas a 10% lightening may eliminate a highlight, it may have no perceptible effect on a black. This means that a print can be pulled early from the bleach and the subsequent toning bath will only tone those areas that have been bleached.

This might be just the lightest of tones to simply give a subtle warm-tone paper effect, or it may be allowed to

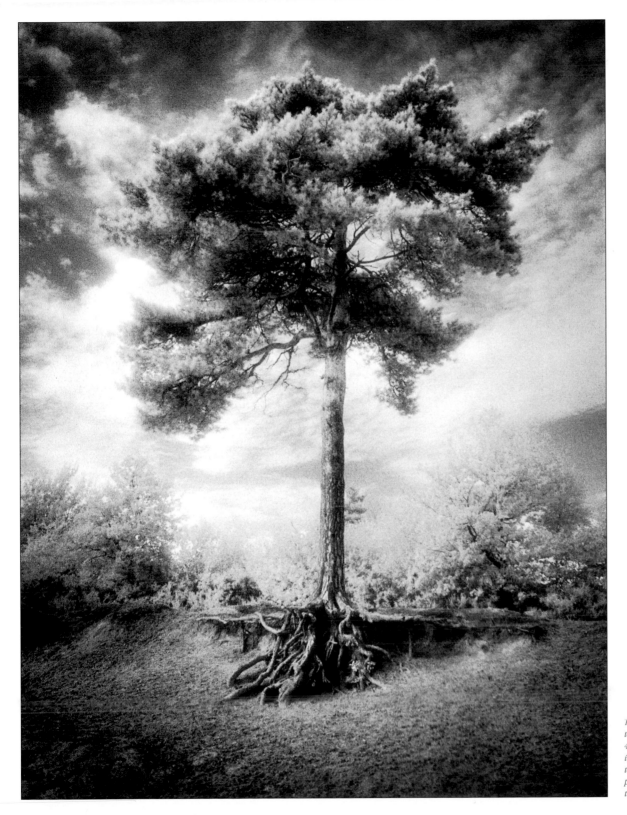

This print works much better as a thiocarbamide split-toned print than as the lith print seen earlier in Chapter 4 (Taking Control of the Process), where it was used to illustrate contrast control in lith printing. Here the toning and printing have been used to flatten the perspective, and create an artificial looking backdrop to the tree.

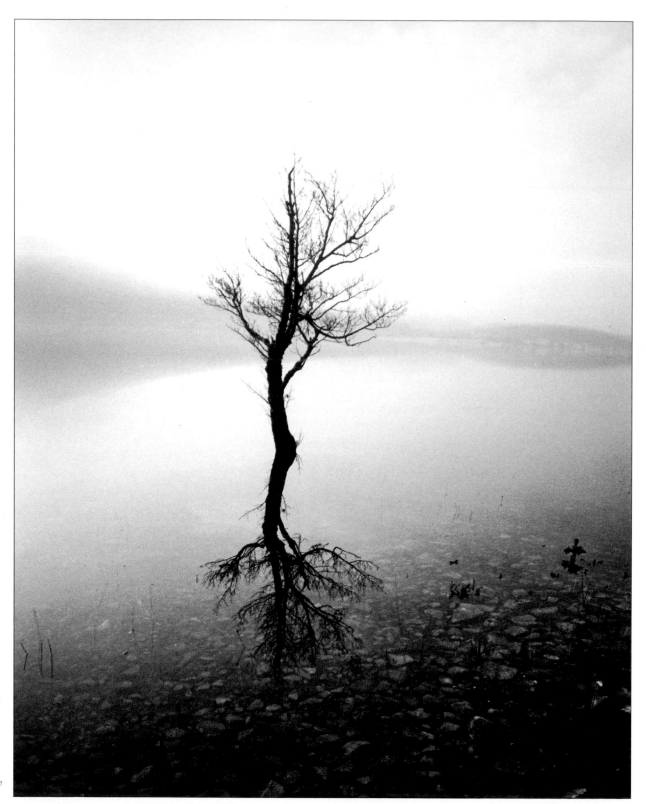

Split-grading was used here to first establish the density of the blacks that are essential to this image and then to lay down the softer tones which will take up the thiocarbamide toner in subsequent split-toning.

Although split-toned prints can superficially resemble lith prints, they respond quite differently to gold toning, giving delicate pink tones instead of the blue seen with a lith print.

extend into the mid-tones for example – giving whites and blacks with brown in between. It can even be used for triple-band toning, where a brief bleach is followed by a light-brown toning bath, and another brief bleach by a dark-brown toning bath (or vice versa even).

To obtain even bleaching and consequently even toning, it is customary to dilute the bleach to slow it down. As bleaches differ in strength, trial and error is the order of the day, but as a guide I use either the formula shown on page 79 or Fotospeed's bleach at between 10% and 30% of the recommended strength depending on the effect I want.

• Split-grade to split-tone
With variable contrast papers it can be helpful to use a split-grading technique in the printing, in order to enhance the results of the subsequent split-toning. Using the Venetian Alley picture on page 102 as an example, it can help to drop in a little extra grade five exposure. This will have little if any effect on the highlights, but will help the blacks to resist the slight browning effect of the split-toning, thus keeping them a colder black.

This particular print also required an extra grade zero exposure to the vertical strip of highlight, that is the corner of the wall. This ensured it picked up a brown tone rather than being rendered white.

This simple technique can sometimes look very lith-like. However if such a print was to be gold-toned, it would not produce the lovely blue that one associates with a gold-toned lith print – instead the sepia-toned areas would turn pink or red in the gold toner.

The two accompanying tree pictures illustrate this. Although having certain obvious design similarities, the ambience and feeling of the two pictures are quite different.

The first is an image used earlier in the book to illustrate contrast control on Sterling Lith paper, and is an example of a picture that works much better here as a split-toned print than as a lith print. Split-grading was only used in highlight control after the main exposure to ensure colour would appear where I wanted it, and to flatten the ariel perspective in order to aid the artificial two-dimensional appearance. It reminds me of a painted theatre backdrop. The soft lith-like colour further abstracts it from reality.

The second tree was split-graded in the initial exposure with grades one and five on Ilford Multigrade IV FB paper. This was in order to create the so essential deep blacks in the tree and then separately control the misty highlights behind, and on, the water's reflection. Subsequent bleaching enhanced the burning-off mist

effect and split-sepia toning was followed by a short dip in gold toner to introduce this lovely soft pink – quite different to the blue colour which gold toner would have produced on a lith print.

BLEACH-BACK
This is a term often used to describe the overall bleaching-back of a silver halide print in a bath of weak bleach to a variable – but always incomplete – degree.

The bleach used is once again potassium ferricyanide – or for those with a chemical bent K3 Fe (CN)6 a.k.a. potassium hexacyanoferrate (III) – but mercifully usually referred to as "ferri"!

The effects obtained vary with the make-up of the bleach, with the paper used and how it is exposed.

• Ferricyanide or Farmer's?
If you have read Chapter 9 (Bleach and Re-development Games) you will be aware of the difference between ferri and Farmer's solution, and the important implications to your print washing technique.

Farmer's solution is a mixture of ferri and hypo (or any fixer will do) and its action is strictly one way – irreversible. As soon as the silver in the emulsion is bleached by the ferri, it is removed by the fixer and is therefore no longer available for re-development.

Ferri solution by itself is reversible because the silver is not removed, as there is no fixer to remove it. It can therefore be re-developed if required. I cannot stress too strongly the importance, when using ferri alone, of removing all fixer products from fibre-based prints at the hypo-clear/washing stage in order to prevent traces of it combining with ferri to form irreversible Farmer's bleach, which will compromise re-development toning of the highlights.

Either Farmer's solution or ferricyanide alone can be used for bleach-back effects. There are however certain advantages in using plain ferri for this. If the bleaching is allowed to proceed too far, or if you do not like the results you are getting, the print can be put back into developer, the image recovered and the process either started again or abandoned.

There are also differences between the two solutions in terms of the effects they can produce.

• The Farmer's Way
The strength of Farmer's solution is entirely dependent on the concentration of ferricyanide in it. The amount of fixer is not critical at all. If the fixer is too strong, the resulting mixture simply goes off very quickly, losing its yellow colour and along with it, its bleaching ability.

Tip

1). All papers do not behave in the same way, particularly where non-standard development or bleach processes are concerned. If you don't get the effects you want try another paper – or two.
2). For split-thiocarbamide toning extreme dilution of the bleach – say below 10 or 20% – should be undertaken only if the lightest tones alone are to be bleached and toned. It is my experience that if these very dilute bleach solutions are used to bleach the image almost back to the blacks, it is more difficult to keep the black tones cold and unaffected by the toner than it is if a stronger – say 30% to 40% – bleach is used. Remember that commercial kit bleaches can vary in strength.
3). When partially bleaching, either for split-tone effects or for bleach-back, always pre-soak the print thoroughly in water to ensure even results. This is especially important with fibre-based papers.

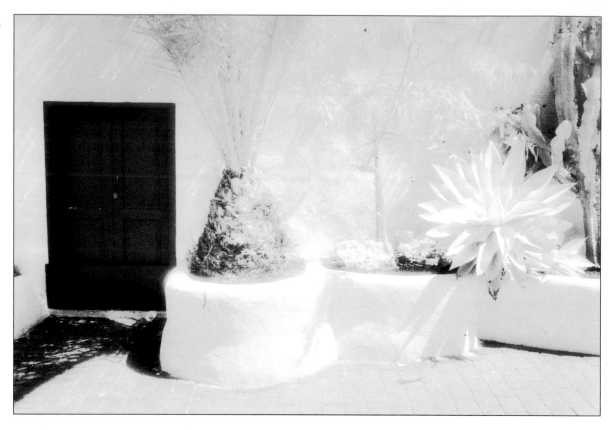

Weak solutions of Farmer's are often used as a print bath just to brighten highlights without producing any colour change. Technique varies from person to person and according to the delicacy of the highlights to be brightened, but anything between 1 and 10ml of 10% stock solution of ferricyanide into one litre of weak – say 25% – fixer works well.

For bleach-back however the bleaching must go further in order to give whitening of the highlights and a yellowish colour to the light mid-tone band. This is achieved either by bleaching longer or stronger – or both. It is usually carried out in association with over exposure of the print and the strength of the bleach coupled with the over exposure given determines the result. Over exposure is typically a $^{1}/_{2}$ to 1 stop, but can be more or less. Highlights and upper mid-tones are stripped away if less over exposure is used, stronger blacks and deeper mid-tone colours result if more exposure is used.

The overall effects can tend toward the coarse with marked rise in grain and contrast, lacking both the subtlety of a hard in the shadows, soft in the highlights lith print as well as other lith characteristics. The procedure therefore particularly lends itself to images of a graphic or gritty nature.

The Soft Touch

My preference for the print shown here and similar images is for the quite subtle and lovely effects that can be achieved by using weak ferri alone.

Here we see ferricyanide behaving quite differently with minimal effect on highlights or on grain. In contrast to The Farmer's Way, very gentle colours can be produced or even hinted at in the mid-tones, giving a lovely combination of ice-cold highlights, beige or putty coloured mid-values and black shadows.

Quite amazingly, even the gentlest of highlight detail can remain preserved by giving just $^{1}/_{4}$ stop over exposure. Stronger effects follow more over exposure and longer bleaching.

I use just 5-10 ml of 10% stock ferri solution into one litre of water for this and bleaching takes between 15 and 25 minutes, depending on how far I want the beige tones to infiltrate into the tonal range. The dish must be gently agitated throughout in order to ensure even results.

If on washing and/or drying the effect is not as desired, the print can be either bleached on, or re-

developed and re-bleached. This double cycle can sometimes give nicer effects.

Finally the print needs fixing, at which point the colour often changes slightly, although papers vary in this respect.

Usually this enhances the warm-cold split effect, giving icy whites and light greys in the highlights in strong contrast to the putty coloured mid-band.

Caution: It is important to very thoroughly wash before fixing, otherwise sudden lightening will occur due to unwanted bleaching! A gentle fixer such as dil sodium thiosulphate is preferable.

Papers
My favourite paper for this treatment has always be Multigrade FB – sadly this has been superseded by Multigrade IV FB. Although superior for printing, the split-effect with weak ferri is marginally cooler in col and slightly less pronounced than its predecessor. Th colours may improve on drying but seem to lighten slightly more in the fix – but it still works. Ilford Warmtone behaves quite differently, giving a soft, ge pinkish image with no warm/cold split, resembling a light lith print. Kentona is different again. The message here is try everything – assume nothing!

Commercial Kit Bleaches
Bleaches out of sepia toning kits can also be used for bleach-back techniques, although they must be greatly diluted from the manufacturer's recommended strengths, as these are devised for toning processes that require total, or at least substantial, bleaching away of the image.

The results obtained are different from either of the two described above and may vary slightly from one make to another, as their formulations are not identical.

They are however all based on a mixture of potassium ferricyanide and potassium bromide. This is easy to make in your own darkroom, as a 10% potassium bromide stock solution is nearly as useful as a 10% ferri stock – possibly more if you do a lot of lith printing or if you keep your papers past their best (it is a useful anti-fogging additive).

If you add 10ml of 10% potassium bromide to the 10ml of 10% ferri in one litre as used in the Soft Touch left, the first thing you will notice is that the bleaching is faster. It is also more aggressive – stripping out some of the highlights that are preserved with very weak ferri alone, coarsening the grain and increasing contrast. The effect is somewhere between Farmer's and very weak ferri, although of course it is still reversible. It becomes more controllable if diluted further, say into two or even

make of paper to another and some papers, which do not normally lith print, will produce very lith-like results.

Either gold or selenium toner can be used, so it is worth experimenting with both to get the effect you want on a particular paper. The example here was printed rather soft on Sterling's RC VC, a paper capable of remarkably colourful results with bleach and re-development techniques, as we have already seen in Chapter 9 (Bleach and Re-development Games). The print was bleached-back to the near blacks, washed and soaked in gold toner until no further change occurred. The time will depend on the freshness and temperature of the gold toner, and in this case was about 20 minutes.

As always, the final results depend on the amount of bleaching permitted. More re-development is likely to occur in selenium, but more graphic images like the image on page 109 may look better in gold, but bear in mind that all papers do not respond in exactly the same way.

Ferri Bleach 10%

Weak Farmers 1 – 10 ml (10% F)
to 1 lit. weak fix (25%)

Ferri alone – reversible

Bleach 'n' tone effects can often produce good lith look-a-like results.

The final print on the right was made on Sterling RC VC paper, printed at grade one and a half. This was partially bleached in a diluted ferricyanide/potassium bromide bleach at 20% of the recommended strength. The print was then transferred to gold toner without prior re-development.

Prolonged toning may be necessary with this technique. The bleach has enhanced the infra-red halation around the figure.

Selenium can produce similar results that often more closely resemble the colours of a typical Sterling Lith print, although I prefer the effect of gold toner with this image.

The prints on the left are (top) a straight print on Sterling RC VC at grade one and a half, and (below) a lith print on Maco Expo RF, developed in LD 20 lith developer.

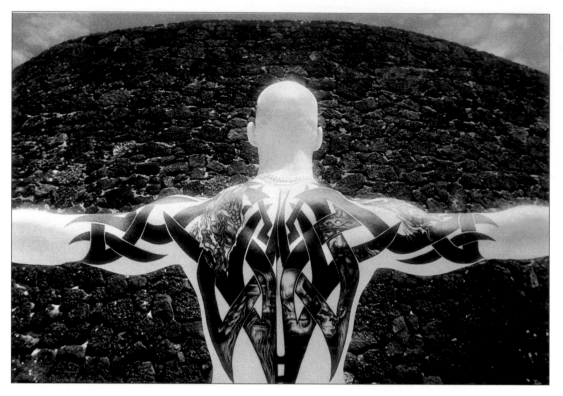

FINAL THOUGHT

Remember – the more you print, the luckier you get!

Lith Printing Trouble Shooting Guide

EFFECT	POSSIBLE CAUSE	REMEDIAL ACTION
Too much contrast	Under exposed	**1).** Increase exposure first **2).** Try pre-flash with care if necessary
Flat prints	**a).** Over exposed **b).** +/- Over flashed **c).** Exhausted or over oxidised developer **d).** Excess Sulphite/Bromide **e).** Safelight faults	**a).** Cut exposure **b).** Cut pre-flash **c).** Replace, or replenish removing half volume of old developer. See Chapter 5 & Chapter 6 **d).** As c). **e).** Carry out safelight tests in Chapter 2
Poor blacks	**a).** Exhausted developer **b).** Excess Sodium Sulphite (re-absorption) **c).** Too much bromide **d).** Wrong exposure **e).** Snatched too early	**a).** Replenish or replace. See Chapter 6 **b).** i) increase dilution ii) increase dilution and add more fresh developer iii) fresh chemicals **c).** Mix new developer and a little old brown. See Chapter 6 (Takeaway Tip 3) **d).** Vary exposure in 1 stop increments, then fine tune. **e).** Extend development
Blocked up blacks	**a).** Over developed **b).** Is contrast too high?	**a).** Snatch earlier for main blacks or dodge 'secondary blacks' **b).** See above
Fogged border/highlights	**a).** Chemical fogging. Tired developer **b).** Unsafe safelighting	**a).** Try more bromide and/or sulphite (if dev not old). Replace or replenish. Consider bleach bath – **caution: colours change,** results vary considerably with paper, best reprint **b).** Carry out safelight tests in Chapter 2
Light tones too pale	Under exposed	Increase exposure
Rash of black dots including highlight areas	Pepper fogging	Add Sodium Sulphite and/or Potassium Bromide
Solitary black dots	Occurs at random on occasional sheets, mostly with MACO Expo and Bromofort	Bleach out with iodine bleach Usually simpler to reprint
Streaking, flow patterns	Stop bath too strong (some papers only)	Add water to stop bath
Blotches, black patches on image or borders	Chaotic infectious development. Usually from contamination and poor technique.	Clean up your technique. Wash hands more thoroughly between prints. Change type of latex/rubber gloves if used (vinyl better) Consider Sulphite addition (see Chapter 6)
Poor lith effect	**a).** Unsuitable paper **b).** Developer too fresh or strong **c).** Developer too old	**a).** Change paper **b).** Increase: dilution, old brown, temperature **c).** Start again
Poor colours	As above	As above. Try toning away.

Paper Characteristics of Papers Discussed in this Book

See also:

1). Paper speed chart.

2). Processing/drying/toning colour flowchart.

3). US/UK/Australia paper equivalents table.

Paper Name	Fibre/ Resin	Surface	VC/graded	Emulsion	Safelight (alternatives In brackets with extra care)	D. Max	Lithable?	Bleach/ Re-develop-	Toning	Remarks
Sterling Premium F Lith	FB	Eggshell (semi - matt)	Gr. 3 approx.	Chloro-bromide	Deep red	1.60	Yes Classical lith print colours	No	Selenium: yes Gold: yes	Currently the only dedicated lith paper. Grades 0-6+ in processing. Prone to pepper fogging (controllable).
Sterling Pro RC VC	RC	1) Oyster 2) Glossy	VC	Chloro-bromide	Deep red (Kodak 0C. Ilford 902 with care)	2.10	No	Excellent	Varies with processing.	Some of the most vivid colours or most unusual effects are shown best with this paper on bleach and lith re-developm't.
Sterling Premium FB VC	FB	Glossy	VC	Chloro-bromide	Deep red (Kodak 0C. Ilford 902 with care)	2.20	No	Excellent	Varies with processing.	Exactly as Pro RC VC.
Sterling Signature Premium F VC warm	FB	Glossy	VC	Chloro-bromide	Deep red (Kodak 0C. Ilford 902 with care)	2.30	No	Yes	Varies with processing.	Warm tone silver rich emulsion. Bleach/ lith re-developm't effects but colours diminish on dry-down.
Kentmere Kentona	FB	1) Glossy 2) Stipple	Gr. 2	Chloro-bromide	Kodac 0C Ilford 902 (red)	2.10 air dried 2.20 heat dried	Yes. Pink/ magenta	Yes	Selenium: yes Multicolour effects Gold: yes	Liths to pink. Goes to maroon/orange by high temperature and/ or turbo fix-up techniques. Fabulous in Selenium. Watch for fogging.

SAFELIGHT NOTE: Where red is given as an alternative to amber/brown, no extra care is required. If an alternative to dark red, extra care *is* required.

(Continued overleaf)

Paper Name	Fibre/ Resin	Surface	VC/graded	Emulsion	Safelight (alternatives in brackets with extra care)	D. Max	Lithable?	Bleach/ Re-develop-	Toning	Remarks
Kentona Art Classic	FB	Heavy-weight textured art paper	Gr. 2	Chloro-bromide	Kodac 0C Ilford 902 (red)	1.60	Yes. Pink/ magenta	Yes	As Kentona but multi-colour selenium effects more restrained (? emulsion or surface texture effect)	Reacts very much like Kentona in all respects – see toning comment. Accepts hand-colouring.
Kentmere VC Select	RC	1) Glossy 2) Satin 3) Fine Lustre	VC	Bromo-iodide	Kodak 0C or 1A Ilford 902 (red)	Glossy 2.20 F. Lustre 2.20 Satin 1.90	No	Yes	Varies with processing.	Pink/grey or red/black on lith re-developm't. Darker tones if over exposed.
Kentmere Fineprint VC	FB	1) Glossy 2) Fine Grain (semi-matt)	VC	Bromo-iodide	Kodak 0C or 1A Ilford 902 (red)	Glossy 2.20 Fine G 1.60	No	Yes	Varies with processing.	Pink/grey or red/black on lith re-developm't. Darker tones if over exposed.
Tetenal/Baryt Vario	FB	Glossy	VC		Kodak 0C or 1A Ilford 902 (red)	2.2	No	Yes	Varies in processing.	Pinks/reds on bleach and re-developm't.
Fotospeed Tapestry	FB	Heavy-weight heavily textured art paper	Gr. 2	Chloro-bromide	Kodak 0C Ilford 902 (red)	1.60	Yes	Pinks/reds	Selenium: yes Gold: yes As Art Classic	Colours can be varied with high temperature and turbo fix-up techniques. Accepts hand=colouring.
Kodak Kodagraph Transtar TP5	RC	Matt	Gr - single	Not stated	Kodak 1A/ light red with care	Not stated	Yes. Very easily. Pink or brown with good blacks.	Yes. Chemical. solarisation and colour effects.	Selenium: yes Gold: yes Very good for dual toning.	Accepts pencil and colouring. Only sold in boxes of 100 sheets. Primarily for use in Graphic Arts work.
Ilford Multigrade Warmtone	FB & RC	Glossy	VC	Chloro-bromide	Ilford 902 and SL1 Kodak 0C	2.20	Yes	Yes. Various colour combi-nations.	Selenium: yes Gold: yes (slow)	Lith effect more subdued and under-stated with less colourful results. Many possibilities on bleach and re-developm't.
Forte Polywarm-tone	FB & RC	1) Glossy 2) Semi-matt	VC	Chloro-bromide	Dark red **with care**	Glossy 2.15 semi-matt: RC 1.90 FB 1.50	Yes	Yes. Lith look-a-like	Selenium: yes. Gold: yes	Also an excellent black and white paper for general use.
Forte Fortezo	FB	1) Glossy 2) Semi-matt 3) Matt 4) Lustre	Graded	Chloro-bromide	Orange or yellow green	Glossy 2.10 Lustre 1.85 semi-matt 1.55	Yes	Yes. Lith look-a-like	Selenium: yes. Gold: yes	Also an excellent black and white paper for general use.

Paper Name	Fibre/ Resin	Surface	VC/graded	Emulsion	Safelight (alternatives in brackets with extra care)	D. Max	Lithable?	Bleach/ Re-develop-	Toning	Remarks
Forte Polygrade	FB & RC	Glossy	VC		Red	Glossy 2.15 semi-matt RC 1.90 FB 1.50	Yes	Yes	Selenium: yes. Gold: yes.	More peachy-beige in lith than Polywarmtone or Fortezo
Forte Bromofort	FB	1) Glossy 2) Dead matt	Graded		Orange or yellow green	Glossy 2.15 matt 1.35	Yes	Yes	Selenium: yes. Gold: yes.	More peachy-beige in lith than Polywarmtone or Fortezo
MACO Expo RR, RF, RN	FB	1) Glossy (RF) 2) Filigree (RR) 3) Deep matte (RN)	Graded	Chloro-bromide	Red or yellow green	RF 2.25 RR 2.00 RN 1.75	Yes	Similar to Sterling RC VC	Selenium: yes. Gold: yes.	New range of papers. No pepper fogging - less graphic than Sterling Lith but like Sterling good for both soft high-key and high contrast impact pictures. Tones well but not as enthusiastically as Sterling Lith.
Oriental Seagull G	FB	Glossy	Graded	Chloro-bromide	Yellow green	2.20	Yes	*	Selenium: yes. Gold: yes.	Excellent, high quality, all round exhibition paper, which also lith prints easily.
Seagull VC FB	FB	Glossy	VC	Chloro-bromide	Kodak 0C Ilford 902	2.20	Yes	*	Selenium: yes. Gold: yes.	Excellent, high quality, all round exhibition paper which also lith prints easily.

* Not currently available in UK for testing. Info based on previous experience with this paper.

IMPORTANT...STOP PRESS

Emulsion Changes – Just as this book is going to press, I have heard that Kentmere are to change the emulsion they make for Kentona, Art Classic and Tapestry papers, in order to remove the cadmium it contains.

Although samples of the new emulsion are not yet available it seems reasonable to expect that this will have a significant effect on the way these papers respond to lith printing and toning.

Colour Guide for Lith Printing and Toning

Colours are not always what they seem in lith printing as many papers change colour through processing and again on drying. In addition, the 'final' colour in the wash can be but a stepping stone to a range of very different colour effects. This table will provide a useful reference to the colour characteristics of some of the main lith papers.

When using this guide please remember;

1). The colours after fixing depend greatly on variable factors like the developer maturity and your technique. It also varies with contrast, in high or low key prints and with snatch-point.

2). The range of colours in Selenium and Gold do depend on the colours produced in the pre-toning processing and in some cases the response to toners may be different because of this. Details are given in the relavent sections of this book.

3). This information is based on my own practice and techniques. Variations can, and do, occur with different techniques.

Note: US/Australian readers are also referred to the paper equivalents table.

Paper	In Developer	In Fix	When Dry	In weak Ferri	In weak Sepia bleach (Ferri/Pot. Brom.)	In Selenium toner	In Gold toner
Sterling Lith	Light purple/lilac	Yellow/beige	Pinky-beige	Cooler browns	Pink, violet/lavender grey	Goes pinker then brown to plummy-brown. Hot 'n' strong method: cold grey, then brown. Splits effectively.	Brown (wet) to cooler brown, grey or gun-metal, to blue, to bright blue.
Tapestry	Lilac/purple	Beige/brown	Pink/red orange* maroon*	Brown or bluey-brown	Greys or lilacs. Brown in Farmer's	A variety of coloured effects is available depending on the pre-toning colour and contrast and the time at which the print is taken from the selenium. Pink blue and blue/brown splits are easy and attractive	Brown, tan, or golden* (wet) to pinks, reds, mauves, purples and then blue.
Kentona	Mauve	Tan or golden	Pink red orange* maroon*	Red prints go brown. Pink or orange prints go a bluey-brown.	Variety of colours including purples and lilacs depending on starting colour. Brown in Farmer's	As Tapestry. Kentona may give a bigger range of colours on the print at one time.	Brown, tan, or golden* (wet) to pinks, reds, mauves, purples and then blue.
Art Classic	Lilac/purple	Beige/brown	Pink/red orange* maroon*	Browns or bluey-browns	Greys and lilacs. Brown in Farmer's	As Tapestry	Brown, tan, or golden* (wet) to pinks, reds, mauves, purples and then blue.

* 'fix up' or high temperature techniques

Paper	In Developer	In Fix	When Dry	In weak Ferri	In weak Sepia bleach (Ferri/Pot. Brom.)	In Selenium toner	In Gold toner
TP5	Purple or mauve	Brown	Pink, red, brown/pink	Cooler tones	Cold tones	Initially goes pinker changing through magenta to cooler purply-browns. Purple/brown split possible. Varies according to starting colour.	Brown (wet) to pink to purple to blue. Blue/brown split possible. Dual selenium and gold for brown and blue is easy and effective with this paper.
MGWT	Blue/lilac	Ivory	Ivory. Hints of pink or lilac.			Blacks colder. Hints of pink. May go to reds (hot).	Slow response in terms of a lith print. Bluey-grey.
MACO Expo R Series: RR, RN, RF	Blue	Brown	Pinky-sepia. in high-key to dark chocolate in low-key.	Cold brown. Highlights clear well. No benefit for colour control, good for cleaning up.	Cold brown. Highlights clear well. No benefit for colour control, good for cleaning up	Initially dark tones colder blacks in contrast with warm highlights. Change to plummy-blacks, then chocolate then warm or gingery-browns. Doesn't give brown/grey split in hot 'n' strong.	Cools to black and white bromide look. Slowly goes to purple-black and purple-blue More purpley than selenium. Unlike TP5 doesn't go through blue/brown split.
Forte Fortezo Museum	Pink	Brown	Brown/orangy brown. Or beige with pink mid-band.	Colder. No benefit.	Similar to Sterling Lith but less marked.	Similar to Sterling Lith, splits with hot 'n' strong technique, but less marked.	Can give lilac/brown split in lighter prints developed to warm tones - progresses to purple and black, then to blue.
Forte Polywarmtone	Lilac	Brown	Cool brown can be processed for warm brown. Cooler than Fortezo.	Colder. No benefit.	Similar to Sterling Lith but bright ginger-brown on re-development in Novolith.	Cools at first, then to warmer brown. Does not split as well as Fortezo.	Initially cooler brown then similar to Fortezo.
Forte Polygrade	Lilac/grey	Fawn	Very little change. Warms slightly.	Bleaches with little colour change.	Bleaches quickly – colder tones.	Initially little colour change for a lith print, slightly warming. Some increase in D max. Eventually goes to very warm brown.	Initially little colour change for a lith print. Cools to bluey-grey. Slow. Go and have a cup of tea! Eventually gets to muted blue. Never to azure blue of other papers.
Forte Bromofort	Lilac/grey	Cooler beige	Little change	Very slight. Warming only.	Colour bleaches out quickly.	Warm brown. Quicker than polygrade.	Bluey-grey.

Paper Speed Quick Reference Table

When lith printing with a variety of different papers, the following paper speed table should facilitate switching from one paper to another without having to make new test strips in normal developer every time.

PAPER SPEED

This is a numerical value which is "inversly related to the exposure required to produce an excellent print". The present standard is based on the exposure needed to produce a midtone. This facilitates comparison of different contrast grades. Softer papers - or softer grades of VC papers - usually have faster speeds than do hard papers, or higher grades of VC papers.

Paper	Grade	Paper Speed
Sterling Premium F Lith	Gr. 3	450P
Sterling Pro RC VC & Sterling Premium F VC	No filter Gr. 0 - 3.5 Gr. 4 - 5	400P 160P 80P
Sterling Premium F graded	Gr. 1 - 3 Gr. 4 Gr. 5	350P 250P 100P
Sterling Signature	Gr. 1 - 3 Gr. 4	350P 250P
Fotospeed Tapestry	Gr. 2	160P
Kodak Transtar TP5	Not given	Not stated. Approximately equivalent to Sterling Lith
Ilford MG IV	No filter Gr. 0 - 3.5 Gr. 4 - 5	500P 200P 100P
Ilford MG WT	No filter Gr. 0 - 3.5 Gr. 4 - 5	200P 100P 50P
Kentmere Kentona	Gr. 2	160P
Kentmere Art Classic	Gr. 2	160P
Kentmere VC Select & Kentmere Fine Print	No filter Gr. 0 - 3.5 Gr. 4 - 5	640P 320P 160P

Paper	Grade	Paper Speed
Forte Polywarmtone	VC	*
Forte Fortezo Museum	Gr. soft	160P
	Gr. normal	160P
	Gr. hard	125P
Forte Polygrade		*
Forte Bromofort	Gr. soft	250P
	Gr. special	250P
	Gr. normal	250P
	Gr. hard	160P
MACO Expo RR, RN, RF	Gr. 2	125/150P
	Gr. 3	125P
	Gr. 4	100/125P
New Seagull G	Gr. 2	640P
	Gr. 3	400P
	Gr. 4	200P
New Seagull Select VC-FB	VC	100 - 400P

*Still unavailable from Forte at time of going to press.

Safelight Code/Colour Table

Note:
Orthochromatic = sensitive to blue/green wavelengths
Panchromatic = sensitive to all wavelengths

Ilford

902	light brown	blue sensitive materials
904	dark brown	fast blue sensitive materials. line film
906	dark red	orthochromatic materials
907	dark green	slow panchromatic materials
908	very dark green	all panchromatic materials
915	light red	orthochromatic Graphic Art materials

Kodak

00	light yellow/brown	slow blue sensitive materials
0A	green yellow	fast blue sensitive materials
0C	light amber	blue sensitive materials
1	red	slow orthochromatic materials and fast blue sensitive materials
1A	light red	Kodalith materials
2	dark red	fast orthochromatic materials

Paterson

	orange	non orthochromatic materials. printing papers unless specified red
	red	blue sensitive and orthochromatic materials

F-stop Chart

-1 stop	-¾ stop	-½ stop	-¼ stop	Basic exposure in seconds	+¼ stop	+½ stop	+¾ stop	+1 stop	+1½ stops	+2 stops	+2½ stops	+3 stops	+3½ stops
0.5	0.6	0.7	0.8	1	1.2	1.4	1.7	2.0	2.8	4.0	5.7	8.0	11.3
1.0	1.2	1.4	1.7	2	2.4	2.8	3.4	4.0	5.7	8.0	11.3	16.0	22.6
1.5	1.8	2.1	2.5	3	3.6	4.2	5.0	6.0	8.5	12.0	17.0	24.0	33.9
2.0	2.4	2.8	3.4	4	4.8	5.6	6.7	8.0	11.3	16.0	22.6	32.0	45.3
2.5	2.9	3.5	4.2	5	5.9	7.1	8.4	10.0	14.2	20.0	28.3	40.0	56.6
3.0	3.5	4.3	5.0	6	7.1	8.5	10.1	12.0	17.0	24.0	33.9	48.0	68.0
3.5	4.1	5.0	5.9	7	8.3	9.9	11.8	14.0	19.8	28.0	39.6	56.0	79.2
4.0	4.7	5.7	6.7	8	9.5	11.3	13.4	16.0	22.6	32.0	45.3	64.0	90.5
4.5	5.3	6.4	7.6	9	10.7	12.7	15.1	18.0	25.5	36.0	50.9	72.0	101.8
5.0	5.9	7.1	8.4	10	11.9	14.1	16.8	20.0	28.3	40.0	56.6	80.0	113.1
5.5	6.5	7.8	9.2	11	13.1	15.5	18.5	22.0	31.1	44.0	62.2	88.0	124.4
6.0	7.1	8.5	10.1	12	14.3	16.9	20.2	24.0	34.0	48.0	67.9	96.0	135.8
6.5	7.7	9.2	10.9	13	15.5	18.3	21.8	26.0	36.8	52.0	73.5	104.0	147.1
7.0	8.3	9.9	11.8	14	16.7	19.7	23.5	28.0	39.6	56.0	79.2	112.0	158.4
7.5	8.8	10.6	12.6	15	17.8	21.2	25.2	30.0	42.4	60.0	84.9	120.0	169.7
8.0	9.4	11.4	13.4	16	19.0	22.6	26.9	32.0	45.3	64.0	90.5	128.0	181.0
8.5	10.0	12.1	14.3	17	20.2	24.0	28.6	34.0	48.1	68.0	96.2	136.0	192.3
9.0	10.6	12.8	15.1	18	21.4	25.4	30.2	36.0	50.9	72.0	101.8	144.0	203.6
9.5	11.2	13.5	16.0	19	22.6	26.8	31.9	38.0	53.8	76.0	107.5	152.0	214.9
10.0	11.8	14.2	16.8	20	23.8	28.2	33.6	40.0	56.6	80.0	113.1	160.0	226.3

-1 stop	-¾ stop	-½ stop	-¼ stop	Basic exposure in seconds	+¼ stop	+½ stop	+¾ stop	+1 stop	+1½ stops	+2 stops	+2½ stops	+3 stops	+3½ stops
10.5	12.4	14.9	17.6	21	25.0	29.6	35.3	42.0	59.4	84.0	118.8	168.0	237.6
11.0	13.0	15.6	18.5	22	26.2	31.0	37.0	44.0	62.3	88.0	124.5	176.0	248.9
11.5	13.6	16.3	19.3	23	27.4	32.4	38.6	46.0	65.1	92.0	130.1	184.0	260.2
12.0	14.2	17.0	20.2	24	28.6	33.8	40.3	48.0	67.9	96.0	135.8	192.0	271.5
12.5	14.7	17.7	21.0	25	29.7	35.3	42.0	50.0	70.8	100.0	141.4	200.0	282.8
13.0	15.3	18.5	21.8	26	30.9	36.7	43.7	52.0	73.6	104.0	147.1	208.0	294.1
13.5	15.9	19.2	22.7	27	32.1	38.1	45.4	54.0	76.4	108.0	152.7	216.0	305.5
14.0	16.5	19.9	23.5	28	33.3	39.5	47.0	56.0	79.2	112.0	158.4	224.0	316.8
14.5	17.1	20.6	24.4	29	34.5	40.9	48.7	58.0	82.1	115.0	164.1	232.0	328.1
15.0	17.7	21.3	25.2	30	35.7	42.3	50.4	60.0	84.9	120.0	169.7	240.0	339.4
16.0	18.9	22.7	26.9	32	38.1	45.1	53.8	64.0	90.6	128.0	181.0	256.0	362.0
17.0	20.1	24.1	28.6	34	40.5	47.9	57.1	68.0	96.2	136.0	192.3	272.0	384.6
18.0	21.2	25.6	30.2	36	42.8	50.8	60.5	72.0	101.9	144.0	203.7	288.0	407.3
19.0	22.4	27.0	31.9	38	45.2	53.6	63.8	76.0	107.5	152.0	215.0	304.0	430.0
20.0	23.6	28.4	33.6	40	47.6	56.4	67.2	80.0	113.2	160.0	226.3	320.0	452.5
21.0	24.8	29.8	35.3	42	50.0	59.2	70.6	84.0	118.9	168.0	237.3	336.0	475.2
22.0	26.0	31.2	37.0	44	52.4	62.0	73.9	88.0	124.5	176.0	248.6	352.0	497.8
23.0	27.1	32.7	38.6	46	54.7	64.9	77.3	92.0	130.2	184.0	259.9	368.0	520.4
24.0	28.3	34.1	40.3	48	57.1	67.7	80.6	96.0	135.8	192.0	271.2	384.0	543.0
25.0	29.5	35.5	42.0	50	59.5	70.5	84.0	100.0	141.5	200.0	282.5	400.0	565.6
26.0	30.7	36.9	43.7	52	61.9	73.3	87.4	104.0	147.2	208.0	293.8	416.0	588.2
27.0	31.8	38.3	45.4	54	64.2	76.1	90.7	108.0	152.8	216.0	305.1	432.0	611.0
28.0	33.0	39.7	47.0	56	66.6	79.0	94.1	112.0	158.5	224.0	316.4	448.0	633.6
29.0	34.2	41.2	48.7	58	69.0	81.8	97.4	116.0	164.2	232.0	327.7	464.0	656.2
30.0	35.4	42.6	50.4	60	71.4	84.6	100.8	120.0	169.8	240.0	339.0	480.0	678.8

Glossary

Anhydrous: Dry form, without water.

Archival permanence: Long lasting – hopefully indefinitely without loss of quality as a result of chemical attack from environment or materials.

Baryta: Barium based substance which stops the emulsion sinking into the paper of fibre-based photographic papers.

Bleaching: Lightening the image by bleaches or 'reducers'. Can be used to lighten selected areas permanently if used with fixer or to bleach away the image prior to re-developing in another developer or a toner.

Bleach-back: The partial overall bleaching of a print in a bleach bath to produce coloured or pseudo lith effects.

Burn-in: Give additional exposure to areas of printing paper in order to produce a darker tone locally when developed.

Caustic: Highly alkaline to point of causing burns.

Cold tones: Tending towards blue/black. Opposite to warm tones which tend towards browns/reds.

Colour down: A term coined by me to describe the colour change in some lith prints on dry-down.

Cropping: Removing part of the image for compositional reasons.

Crystalline: Contains water and forms characteristic crystal shape.

D max: Maximum density available (e.g. deepest black).

D min: Minimum density possible. Lightest tone available.

Density range: Difference between D max and D min.

Developer: Chemical solution to convert the invisible emulsion silver halide into visible metallic silver.

Developer additives: Substances added to developer for old papers, different tones, pepper fogging prevention or other purposes.

Dodging: Holding back exposure from local areas of printing paper in order to produce lighter tones on the print when developed.

Dry-down: Darkening of a print on drying – applies mostly to fibre based prints. Will appear greater if your inspection light is too bright.

Emulsion: The light sensitive surface layer of film and paper. Usually silver halides in gelatin.

Farmer's reducer: A bleach for lightening tones on a print permanently. Made from potassium ferricyanide and hypo fixer.

Fibre-based papers – (FB): Photographic paper not employing resin-coated technology. Handling characteristics are those of paper rather than plastic. Processing times are long. Possibly more archivally permanent than resin coated paper.

Ferri: Potassium ferricyanide. A bleach used in Farmer's reducer and many other bleaching solutions.

Fixer (or Fix): Renders the image permanent. Removes unexposed silver from the emulsion.

Fix-up: Not yet a recognised term. Coined by me to describe the apparent, sometimes dramatic lightening when a lith print goes into the fixer.

Flashing: Exposing the paper to white light to a degree below D min – i.e. producing no tone (or fog) itself on the paper. Reduces contrast. Extends tonal range.

Flash strip: Test strip for flashing – to determine point of maximum flash without fogging.

Fogging: Producing an overall tone or veil either by exposing to white unsafe light past D min or by chemical action.

f-stop: Term used for aperture settings on a lens e.g. f1.4, f2.8, f4, f5.6, f8, f11, f22. The difference between two consecutive aperture settings is 1 f-stop.

f-stop timer: Enlarger timer calibrated to convert f stop instructions into real time.

Grain: Clumping of silver halide grains that make up the image. Unlike film, the grain size on the paper is largely responsible for the image tone (colour) after development.

Hardener: Hardens print (or film) surface after processing. Not advisable if toning or processing for archival permanence. Useful for glazing fibre-based papers or enhancing gloss on resin-coated glossy papers.

High-key image: Image consisting mainly of light tones.

Hypo: Sodium thiosulphate. A fixer.

Hypo-clearing agents: Agents to speed up the efficient removal of hypo or fixer from prints in subsequent washing.

Infectious development: Rapidly accelerating development seen in lith printing.

Latent image: As yet invisible image on paper or film, which will be rendered visible by development.

Lattice: Silver bromide crystallises in a cubic

pattern. The arrangement of atoms on the upper surface of this cube is known as the lattice.

Lith paper: Specialist paper used with dilute lith developer to produce lith prints by infectious development when overexposed and not fully developed.

Low-key image: Image consisting mainly of dark tones.

Max flash: The maximum amount of light to which a photographic paper can be exposed (flashed) yet still shows no tone on development. See **Flash strip.**

Old Brown: Old, used or oxidised developer. May be added to fresh developer when developing for warm tones. Useful in lith printing for more colourful results.

Oxidation: Combines with oxygen to form an oxide. Loses electrons. Opposite of reduction.

Paper inertia: A photographic paper characteristic of requiring a certain amount of light exposure before any tone is visible on development. The flat part of the toe in the characteristics curve. The area before Max Flash.

pH: A scale ranging from 1 to 14 indicating the level of acidity (below 7) or alkalinity (above 7). 7 is neutral.

Pepper fogging: Multitudinous black dots on a lith print resulting from chaotic infectious development. Caused by low sulphite levels in heavily diluted developer. At time of writing confined to Sterling Lith paper. Preventable by adding sodium sulphite, with or without potassium bromide.

Preservative: A substance added to a developer to inhibit its oxidation, whether by air or during the development process.

Pre-visualisation: Visualising the end product before it exists (then adapting procedures to achieve it).

Printing maps: Record sheet showing exposure dodging and burning in plan for a print.

Re-development: Bringing back an image that has been bleached away, by placing in a developer with similar or different characteristics to that which first developed it.

Reduction: Opposite of oxidation. Gains electrons. Loses oxygen. Reduction of a print or negative means lightening by chemical means – either all over or in local areas selectively. See **Bleaching.**

Replenishment: The addition of fresh developer to used stock.

Resin-coated papers – (RC): Photographic emulsion coated onto plastic or resin-coated paper. Chemicals do not penetrate paper fibres and so processing times are short.

Safelight: Light which does not sensitise the photographic materials in use.

Safelight test: A procedure to establish whether a safelight is safe.

Silver halides: Generic name for a group of light-sensitive compounds of silver with a halogen (bromines, chlorines, iodines, fluorines). Hence bromide, chlorobromide and bromochloride papers.

Split grading: See **Split-filtration.**

Split-toning: Toning part of the density range only – either the light, light and mid, mid and dark or dark tones.

Split-filtration: Used with variable contrast papers. Dividing the exposure into sections of different contrast for subtle tonal control.

Stop bath: Acid solution used after developer to instantly arrest development, before paper is transferred to fixer.

Test strip: A paper given a test series of incremental exposures in order to determine the correct exposure.

Toning: Altering the colour of a print chemically. Some toners increase the permanence of the image and may be used for this purpose primarily with, or without, significant colour change.

Variable contrast filters: Filters for use with variable contrast papers to achieve different contrast grades.

Variable contrast paper – (VC): Papers enabling a range of contrasts to be obtained from a single packet – or even on a single print – by exposing through appropriate filters.

Warm tones: Tending to browns/reds. Opposite to cold tones which tend towards black/blue.

Water bathing: A method of controlling print contrast in normal development and colours during re-development in lith developer after bleaching.

White light: Light of uniform density, to which the paper is sensitive. Not projected through a negative. Used in fogging and flashing.

Suppliers – UK, USA & Australia

Agfa Gevaert Ltd.
French's Avenue,
Dunstable,
Bedfordshire,
LU6 1DF
Tel. 01582 473690

C.M. Direct
(mail order papers,
chemicals, equipment)
Creative Monochrome Ltd.,
Courtney House,
62 Jarvis Road,
South Croydon,
Surrey,
CR2 6HU
Tel. 0181 6863282
Fax. 0181 6810662
E-mail. roger@cremono.demon.co.uk

Firstcall
(Photographic Mail Order)
Cherry Grove Cottage,
Gotton,
Cheddon Fitzpaine,
Taunton,
Somerset,
TA2 8LL
Tel. 01823 413007
Fax. 01823 413103

Fotospeed
(raw and prepared chemicals,
papers, old process etc.)
Jay House Ltd.,
Fiveways House,
Westwells Road,
Rudloe,
Corsham,
Wilts,
SN13 9RG
Tel. 01225 742486
Fax. 01225 811801
E-mail. Fotospeed_UK@
compuserve.com

Ilford Imaging U.K. Ltd.
U.K. Sales,
Town Lane,
Mobberley,
Knutsford,
Cheshire,
WA16 7JL
Tel. 01565 684005
Fax. 01565 087303

Jessops Ltd.
(papers and prepared
chemistry, equipment)
Mail Order enquiries:
Tel. 0116 2320432

Kentmere Photographic:
Mail Order Kentmere Ltd.
Freepost,
Staveley,
Kendal,
Cumbria,
LA8 8BR
Tel. 01539 822322
Fax. 01539 821399

Kodak Polychrome Graphics Ltd.
Axis 1
Rhodes Way,
Watford,
Herts.
WD2 4FD
Tel. 01923 655811
Fax. 01923 242642

MACO Photo Products
This is a division of:
Hans O. Mahn & Co.,
P.O. Box 105202,
D – 20036
Hamburg,
Germany.
Hot Line. (++49) 40 2370080
Fax. (++49) 40 233577
E-mail. PHOTO@maco.thn.net

Mr. Cad
(Maco products and
everything photographic)
68 Windmill Road,
Croydon,
Surrey,
CR0 2XP
Tel. 0181 6848282
Fax. 0181 6848835

Process Supplies (London) Ltd.
(papers and chemicals),
13-25 Mount Pleasant,
London,
WC1X OAA
Tel. 0171 8372179
Fax. 0171 837 8551

Rayco Chemical Company
(raw and prepared chemicals,
formulary and toning guides)
199 King Street,
Hoyland,
Barnsley,
S74 9LJ
Tel/fax. 01226 744594

R.H. Designs
(f-stop timer, paper flasher,
darkroom torch etc.)
20 Mark Road,
Hemel Hempstead,
Herts.
HP2 7BN
Tel. 01442 258111
Fax. 01442 258112
E-mail. rhdesign@nildram.co.uk
www.nildram.co.uk/rhdesign

Silverprint Ltd.
(raw and prepared chemistry,
papers, everything for the darkroom
– distributors for Forte)
12 Valentines Place,
London,

SE1 8QX
Tel. 0171 620 0844
Fax. 0171 620 0129
www.silverprint.co.uk

Speedibrews
(chemicals and chemical products)
Mail order only
J. Cottrill Photography,
10 The Triangle,
St. Johns,
Woking,
Surrey,
GU21 1PP
Tel. 01483 772316

Sterling Imaging UK
(Sterling Papers)
Jay House Ltd.,
Fiveways House,
Westwells Road,
Rudloe,
Corsham,
SN13 9RG
Tel. 01225 812531
Fax. 01225 811801

Tetenal Ltd.
(chemicals, papers,
free guide booklets)
9 Meridian Village,
Meridian Business Park,
Leicester,
LE3 2WY
Tel. 0116 263 0306
Fax. 0116 263 0087
E-mail. uk@tetenal.com

Adorama
42 West Eighteenth Street,
New York,
N.Y. 10011
Tel. (800) 8114004
Fax. (212) 463 7223
E-mail. adorama@AOL.com

B & H
(paper, chemistry, equipment)
420 Ninth Avenue,
New York,
N.Y. 1001
Tel. (800) 947 9981
Fax. (800)947 7008
www.bhphotovideo.com

Cachet
(fine art photographic papers –
supplier for MACO products)
3701 West Moore Ave.,
Santa Ana,
CA. 92704
Tel. (714) 432 7070
Fax. (714) 432 7102
E-mail. cachet@fea.net
www.onecachet.com

Calumet Photographic
(for Naccolith
and other materials)
890 Supreme Drive,
Bensenville,
Illinois 40104
Tel. 1 800 CALUMET (225 8638)
E-mail. webmaster@
calumetphoto.com
www.calumetphoto.com/

Luminos Photo Corp.
(see UK/US paper table)
25 Wolffe Street,
Yonkers,
N.Y. 10705
Tel. (914) 965 4800
Fax. (914) 965 0367
www.luminos.com

Photographer's Formulary
(chemistry)
PO Box 950
Condon
MT 59824

Tel. (800) 922 5255
Fax. (406) 754 2896
E-mail. formulary@montana.com
www.photoformulary.com

Sterling Imaging Inc.
(Sterling Papers)
2847 Ruby Avenue,
San Jose,
CA. 95148
Tel. (800) 295 3740/(408) 528 1954
Fax. (408) 528 1953
E-mail. adodras@aol.com

AUSTRALIA

Foto Supplies
494 Dean Street
Albury
NSW
2640
Tel. (060) 216 566

PR Agencies
63 Newcastle Road,
Perth,
WA
Tel. (089) 225 4677

Stallard's Camera House
101 Liverpool Street,
Hobart,
Tasmania,
7000
Tel. (03) 6234 5034

Ted's Camera Store
146 Adelaide Street,
Brisbane,
QLD
4000
Tel. (07) 3221 9911
also at;
NSW – (02) 9264 8499
Victoria – (03) 9602 4632
S. Aus. – (08) 8223 3449
ACT – (06) 247 8711

Use this space to write your own supplier details

Ilford Recommended Archival Washing Programme for Fibre-Based Prints

The rationale behind Ilford's programme is to use their non-hardening rapid fixer Hypam at 1+4 instead of the usual recommended 1+9. Fixing is complete at 30 seconds and should not be allowed to continue for more than 60 seconds.

The strong but brief fixing does the required job but minimises the time that the fixer can infiltrate into the fibre base. This in turn reduces washing time.

1). Develop fully (not if you are lith printing!).

2). Stop bath at full strength for a minimum of 10 seconds.

3). Hypam at 1+4 at 20°C for 30 seconds minimum and 60 seconds maximum.

4). Wash for 5 minutes.

5). Washaid/Hypoclear for 10 minutes.

6). Final wash 5 minutes in an efficient print washer.

7). Air dry.

Note: Fixer should not exceed a silver level of 0.5gm/litre in this programme. This is the equivalent of only about ten 8" x 10" prints per litre. After this the fixer can be used for films or RC paper up to 2G/litre. Silver can be estimated with silver estimating papers.

UK/US/Australian Paper Equivalents

UK	US	Australia
Kentmere Art Classic	Luminos Classic Charcoal R	Fotospeed Renaissance
Kentmere Kentona	Luminos Classic Warmtone	Fotospeed Impressions
Fotospeed Tapestry	Luminos Tapestry X	Fotospeed Tapestry
Kentmere Fineprint VC	Flexicon FB VC	N/A
Kentmere Fineprint Warmtone	Flexicon Warmtone	The Classic
Kentmere VC Select	Flexicon VC	Pro Art
MACO Expo series RF and RN	Cachet/fappco RF and RN	N/A

Sterling, Kodak, Ilford, and Forte papers are sold under the same name in all countries.

Also MACOlith Developer will be distributed in the US and Canada as Cachet/fappco 2 part developer 690

INDEX